Modern Art in English Churches

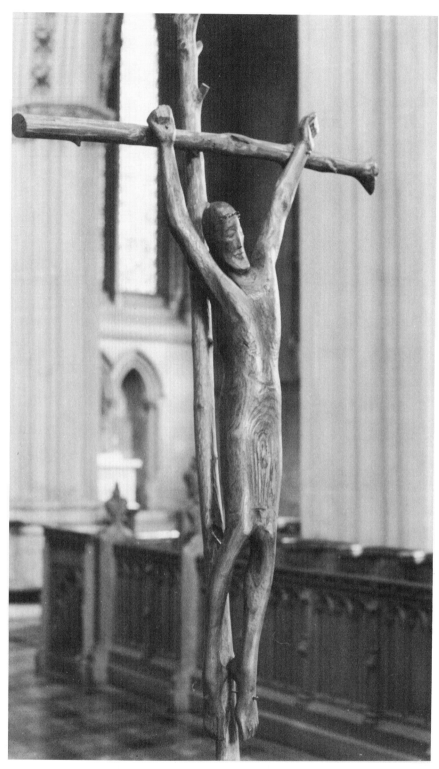

Plate 1 FENWICK LAWSON crucifix (1983), elmwood,
University church of Christ the King, Gordon Square, London

Modern Art in English Churches

by

MICHAEL DAY

MOWBRAY
LONDON & OXFORD

ISBN 0 264 66953 3 (hardback)
ISBN 0 264 66968 1 (paperback)

First published 1984
by A.R. Mowbray & Co. Ltd,
Saint Thomas House, Becket Street,
Oxford, OX1 1SJ

Typeset by Oxford Publishing Services, Oxford.
Printed in Great Britain by Cowells Ltd, of Ipswich

British Library Cataloguing in Publication Data
Day Michael, *1937–*
 Modern art in English churches.
 1. Christian art and symbolism—Modern
 period, 1500—England 2. Art, English
 3. Art, Modern—20th century—England
 I. Title
 704.9'482 N7943

By the same author;
Modern Art in Church, A Gazetteer (RCA)

'God created the arts in order that life
might be held together by them,
so that we should not separate ourselves
from spiritual things.'

<div align="right"><i>St John Chrysostom,
Homily to the Philippians, 10.5</i></div>

Contents

ACKNOWLEDGEMENTS

I wish to thank the various deans of cathedrals, parish priests, heads of religious communities, churchwardens and artists who have patiently answered my numerous questions and have allowed me to take photographs in their churches. I am also grateful to the Publications Officer of the Royal College of Art for permission to use material from a previous book of mine in this subject, to Richard Haigh for reading through the manuscript and to Kenneth Baker of A.R. Mowbray & Company Ltd for his kind help and encouragement. All omissions and mistakes are entirely my own responsibility and I would welcome any corrections and additions that readers may come across.

The Author wishes to express his thanks to the following for permission to reproduce material of which they are the authors, publishers or copyright holders.

The Division of Education and Ministry of the National Council of the Churches of Christ in the USA for extracts from the Revised Standard Version of the Bible, copyrighted 1946, 1952 © 1971, 1973.

Curtis Brown Ltd for an extract from *William Morris: Writings and Designs*, copyright Asa Briggs (editor).

Mrs. F. Ashbee for an extract from *Memoirs Vol. IV* by C.R. Ashbee.

John Murray (Publishers) Ltd for an extract from The Gothic Revival by Sir K. Clark

Oxford University Press for an extract from *The Parson's Handbook* (4th edition, 1903) by Percy Dearmer.

G.J. Palmer & Sons Ltd for a letter to *Church Times*, dated 12 October 1934, from Sir Ninian Comper.

The Bishop and Provost of Coventry Cathedral at the time of its rebuilding for an extract from the Schedule of Requirements and Accommodation.

Studio International for an extract from an article in *The Studio*, dated September 1942, by George Bell.

Mr Tooth, Stanley Spencer's agent, for an extract from a letter to him from Stanley Spencer.

Professor Dr J.P. Hodin for an extract from *XXe Siècle*, dated December 1964, by Dame Barbara Hepworth.

Lawrence Pollinger Ltd for an extract from *Life with Picasso* by Francoise Gilot and Carlton Lake (Thomas Nelson & Sons Ltd).

Richard Courtauld for an extract from *By Chance I Did Rove* by Norman Jewson.

Every effort has been made to trace publishers of copyright material and omission will be rectified in a future edition.

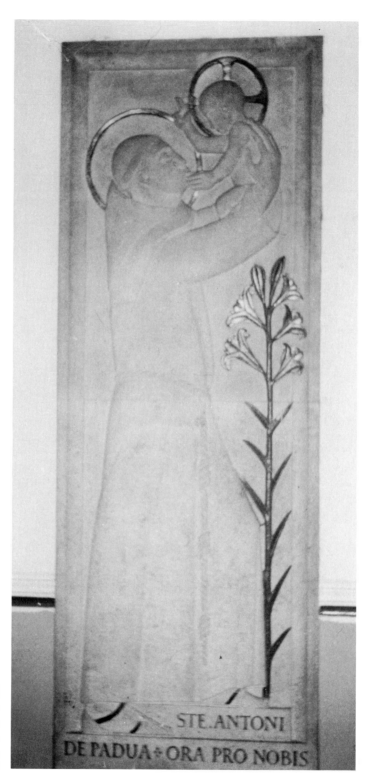

Plate 2
ERIC GILL
St Anthony of Padua,
stone relief,
Church of the First Martyrs,
Bradford

Preface

THIS BOOK is an attempt to discover and examine visual works of art of the twentieth century which are to be found in English churches. There are, scattered up and down the country — in obscure village churches as well as in famous cathedrals — works of art by modern artists which are not only worth looking at but which fulfil their primary purpose of turning minds and imaginations towards God.

It must be admitted that there are some objects in our churches which would best be forgotten, for they are poor and wretched examples of works of art, unworthy of their place in church in any age. The problem is not so much how to dispose of the bad and cherish the good but, first of all, one of discrimination. There is a great, common ignorance about twentieth century art, inside and outside churches, and one of the purposes of this book is to draw people's attention to the works we possess so that their appreciation and critical judgement may be sharpened.

I have restricted myself to looking at paintings, sculpture, stained glass, wall hangings, altar furnishings and vestments made by professional artists, designers and craftsmen of this century; objects which have the primary aim of helping the Christian worshipper, of holding his attention and inspiring his imagination. Church architecture is only mentioned where it has been essential to do so. Nearly all the churches I have mentioned are those of the Church of England and the Roman Catholic Church. The visual arts have not played a consciously significant part in Free Church worship and few of their churches contain objects of visual interest.

In approaching the subject I have taken a religious work of art to mean one that draws the onlooker, as well as the artist, to contemplate *something* which is beyond the work of art itself, *something* which many people call God. For the traditional Christian this will mean the mystery of God the Holy Trinity, very little to do with high thoughts in dim places but a mystery which has with the new order of reality brought about by Christ and active in the sacramental life of the Church.

The aim of this book is to show how important and vital are the visual arts to our experience of Christianity. I hope it will help the reader extend his knowledge of the Christian artistic heritage into the twentieth century and also deepen his awareness of the signs and symbols which point to the glory of God.

South Kensington, 1983 *MICHAEL DAY*

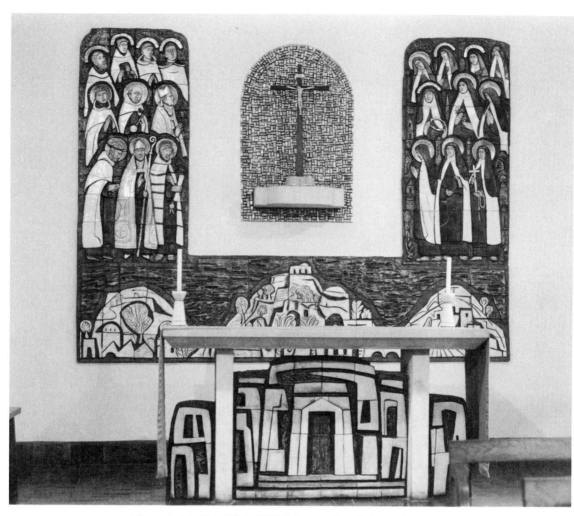

Plate 3 ADAM KOSSOSKI Carmelite Saints, (c.1964),
ceramic tiles, chapel, Aylesford Priory

List of Illustrations

LIST OF ILLUSTRATIONS

Colour Plates (between pages 44 and 77)

LIST OF ILLUSTRATIONS

Monochrome Plates

1. An historical perspective

'GOD SPOKE these words, saying . . . You shall not make yourself a graven image, or any likeness of anything that is in heaven above, or that is in the earth beneath . . . you shall not bow down to them or serve them.' To understand twentieth century Christian art it is necessary to look at its religious roots and also to recognize the ambivalent attitude of the Church to the visual arts. This second commandment has hung, like an accusing finger, over religious imagery.

For most Jews, and for some Christians, there is no problem; the prohibition is final and complete, all representational art leads to the temptations of idolatry. However, most Christians find the problem not that simple and there is room for numerous questions. Is, for instance, the commandment directed against images in themselves or only against their use as idols? All religions have used some kind of art form. Why should the visual arts be singled out as especially liable to evil?

For Christianity the problem has been resolved; Christ has come, the prophecies have been fulfilled and the Law has become a shadow of the good things to come. Christ is the image of God, matter has been filled with grace and power, and no image can now be considered evil in itself. 'In former times,' said St John of Damascus, 'God, who is without form or body, could never be depicted. But now when God is seen in the flesh conversing with men, I make an image of God whom I see. I do not worship matter; I worship the Creator of matter who became matter for my sake.'

The Gospels record Jesus saying a good deal about the use of visual imagery. For Jesus, to look is to understand. In the parables he uses a variety of visual images to convey his ideas. The kingdom of God is like . . . a grain of mustard seed, a sower, a net. 'Consider the lilies of the field', 'Look at the ravens . . .'. His teaching is bound up with ordinary, everyday objects that point his hearers to knowledge about God the Father. Who Jesus is, and what he is about, can be understood simply by *seeing*: 'the blind receive their sight and the lame walk, lepers are cleansed and the deaf hear . . .' Jesus is concerned to open eyes and there is no suggestion that he is using metaphorical language. 'Watch and pray' is a command to keep awake, to be on one's guard, and to use the faculty of sight to recognize the signs of the times so that one can then pray.

During the time of the apostolic Church, men and women who had seen Jesus were of great importance. 'That which was from the beginning, 'says St

1

John, 'which we have heard, which we have seen with our eyes, which we have looked upon and touched with our hands . . . we proclaim also to you.' Once the eye-witnesses were gone it was not only the written word which replaced their testimony, drawings on a wall also helped to teach and to recall the faith.

A VARIETY OF USES

Persecution, demolition and the ravages of time and change have obliterated the earliest Christian works of art. The first paintings to survive are those on the walls of a house church at Dura-Europos in Mesopotamia dating from the middle of the third century, and, slightly later, those in the catacombs under Rome. Nothing about them suggests that they were a sudden innovation nor, apart from their Christian content, are they any different from contemporary pagan styles of painting. The impression they give is that Christians, whenever and wherever they could, produced images of their faith, in buildings they might own, in a manner very little different from other religious and secular paintings of the time. The murals in the catacombs are a mixture of Old and New Testament events; Samson wrestling with a lion looks very like Hercules killing the Hydra in a nearby gallery; Christ is portrayed as the Good Shepherd in much the same way as Orpheus is painted in a pastoral scene from another catacomb.

Once the Church could safely build its own substantial church buildings, the walls are found to be covered by paintings and decorative motifs. The centuries that follow show a rich variety of use in church for the visual arts. They could teach the faith, as St Gregory the Great pointed out, to those who could not read books. They could inspire and overawe the worshipper by the size of the buildings, the riot of colour and the sheer richness of interiors. They could inspire the mystic; as Abbot Suger of St Denis wrote, 'a man could come to a close understanding of the light of God through the light of material objects in the physical world.' Education, inspiration, the commemoration of the saints, the visual symbolism of the liturgy, all these things were ways in which the visual arts have been employed by the Church during its existence.

It must be admitted that the motives for employing the visual arts were often mixed. An impressive building with a magnificent interior could easily reflect upon the prestige of a patron and benefactor as much as upon the glory of God. Renaissance popes and cardinals were as likely to patronize the arts for their own advancement as for the glory of God, and they were not alone in this. However, despite unworthy motives by ambitious men, despite the disapproval and destruction of works of art by many kinds of puritans, and despite the demands of fashion and fad, it is the great variety of use that is the mark of the Church's use of the visual arts. It is a mark that is there at least until the nineteenth century.

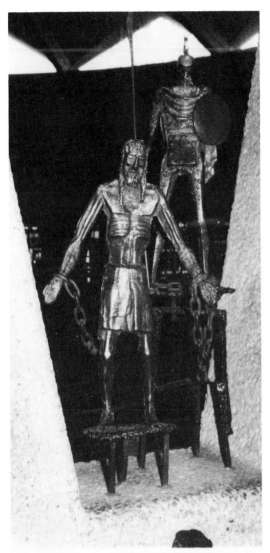

Plate 4
ARTHUR DOOLEY
Station: *Behold the Man* (1962), metal,
St Mary, Leyland

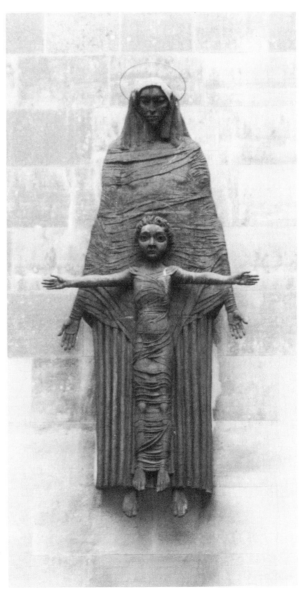

Plate 5
Sir JACOB EPSTEIN
Madonna and Child (1952), lead,
outside wall of Heythrop College,
Cavendish Square, London
*Public approval. A passing London bus driver
stopped his bus and called out to Epstein,
"Hi Governor, you've made a good job of it."*

2. The legacy of the Gothic Revival in the nineteenth century

A LEGACY usually implies a death, but it would be incorrect to suggest that the nineteenth century Gothic Revival style of church architecture and furnishings died out in England with the passing of Queen Victoria in 1901. There was still a great deal of life left in it. However, its influence in church circles was treated very much like a legacy from a dear departed relative; with a certain reverence and a solemn realization of something valuable being handed on. Before turning to the twentieth century, it will be necessary to take a brief look at the Gothic Revival and at several other factors, such as the Arts and Crafts Movement, nationalism and antiquarianism, which have made their contribution to modern religious art in this country.

The Gothic Revival in England had its roots deep in religious conviction. What began with an eighteenth century interest in medieval form and fancies soon developed into ideas about the proper style for building churches. It had become obvious to many at the time that more churches were badly needed. The population was not only growing but was shifting from the countryside into the towns, and the building of new urban churches was necessary. For the aesthetes of the time the Gothic style was one which commanded a sense of awe, admirably suited to a place of worship.

A whole generation of young architects grew up dreaming of Gothic. One such, Augustus Welby Pugin (1812–52) — no dreamer but a campaigner — maintained that medieval society had been more humane, more religious and far better organized than nineteenth century industrial Britain, and during his short life he campaigned tirelessly for a return to medieval ideals and principles. Gothic, he maintained, was the true Christian style of architecture. In it we find '*the faith of Christianity embodied and its practices illustrated.*' (*Contrasts* (1836)). He argued that Christian architecture illustrated Christian belief; the doctrine of the Redemption was demonstrated in the cross plan of medieval churches, the doctrine of the Holy Trinity could be seen in the triple arches and windows of the building, while 'the vertical principle emblematic of the resurrection, is the very essence of Christian architecture'.

Pugin was a convert to Roman Catholicism and considered that Church the only one in which 'the grand and sublime style' could ever really be restored. However, it was the young members of the established Church who took up his ideas and applied them with enthusiasm. Although a romantic liking for Gothic ruins had long been fashionable, Pugin touched tender consciences

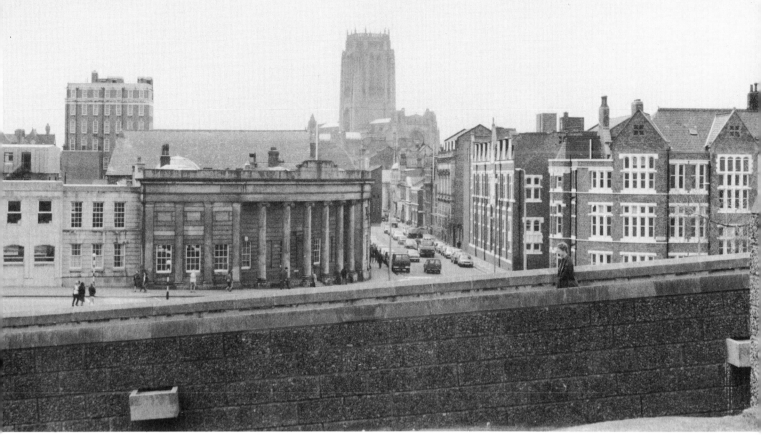

Plate 6
Sir GILES GILBERT
SCOTT
Liverpool Cathedral,
(1904–78), from the north
end of Hope Street.

when he contrasted medieval with nineteenth century society. Also, at the same time, the leaders of the Oxford Movement were teaching Anglicans to discover the past glories of their Church back beyond the Reformation. The result was that undergraduates and architectural apprentices formed clubs to restore and discover the Gothic past, the most famous being the Cambridge Camden Society founded in 1839. They visited old buildings and cathedrals, drew up plans to restore old churches and build new ones, and rescued ancient, crumbling abbey ruins from the pillaging of country people. Gothic was not only a romantic past, it was also a vision for the Church of the future. 'Correctness' was the operative word for the reforming zeal of the societies, and they were not without their eccentric elements. At a meeting of the Ecclesiological Society in 1847, it was seriously proposed, if the funds permitted, that they should pull down Peterborough Cathedral and rebuild it in a more 'correct' Gothic style.

John Ruskin (1819–1900), Slade Professor of Fine Art at Oxford, was deeply interested in Gothic architecture and social reform. What particularly appealed to him about Pugin's ideas was that they made a direct connection between art and morality. 'Good men build good things,' said Pugin and Ruskin approved. He did more than anyone else to promote the idea of 'worthiness' as a necessary ingredient in church art and for those who created it.

By the late nineteenth century the Gothic legacy was fixed. For fifty years almost every new Anglican church was built and furnished according to the instructions of the Ecclesiological Society. Of the eight cathedrals completed in the twentieth century, four were Gothic: Truro Cathedral (1880–1910) by

John Pearson and completed by his son, St Anne's Roman Catholic Cathedral in Leeds (1902–04) by J.H. Eastwood, Liverpool Anglican Cathedral (1904–78) by Sir Giles Gilbert Scott, and Guildford Cathedral (1932–61) by Sir Edward Maufe. The last two were built in highly individual styles of Gothic, but Scott's building raised considerable protests from the architectural community of the day when its plans were first made public. Gothic, for most architects at the turn of the century, but not for the church authorities, was a worn-out style.

NINETEENTH CENTURY RELIGIOUS PAINTING IN BRITAIN

In terms of religion the nineteenth century was not a great period of creative activity. There was a rapid growth in scientific and industrial knowledge during this century, but for Christianity it was more a time of reflection and intellectual stability than one of change and growth. Religious painting was at a low ebb during the first half of the century. With the exception of William Dyce (1806–64), few artists produced anything of note in their commissions for churches. It was the time of the great landscape artists, John Constable (1776–1837) and William Turner (1775–1851); and the painters of the Romantic school were more interested in discovering a general feeling for the numinous among wild and lonely landscapes than within the confines of Christian doctrine.

In 1845, a group calling itself the Pre-Raphaelite Brotherhood was founded by John Everett Millais, William Holman Hunt and Dante Gabriel Rossetti as a reaction to what they considered was the stereotyped medievalism of most historical painting of the day. They turned for inspiration to the time before the high Renaissance as a protest at the increasing materialism they found in the world about them. A great many of their paintings were based upon biblical themes, seen most particularly in the work of William Holman Hunt (1827–1910). Crude in colour and with a didactic emphasis upon social symbolism, his work, with that of his fellow Brothers, was considered shocking to the Victorian standards of piety. They daringly portrayed gospel scenes in a realistic and homely fashion, which provoked the jibe of Charles Dickens that their work was nothing more than 'journalistic realism'.

Their vitality, and their shocks, did not last for long. The Brotherhood dissolved itself in 1853; Rossetti associated himself with Edward Burne-Jones and William Morris, and only Holman Hunt remained faithful to the earlier doctrines of the group. Religious art of the later decades of the nineteenth century is of little interest, being for the most part very sentimental and moralistic. The work of George Watts (1817–1904), the most revered figure in British art of the 1880s, is typical of much that was produced at the time. Uninterested in new ideas from the Pre-Raphaelites or the French Impressionists, he looked back to classical models from Greece and Italy, adding his own brand of moralism to his work.

The turn of the century saw no current or ordered sequence in British painting. Several painters, especially those of the New English Art Club (founded in 1886), had contact with the French Impressionists, but the general atmosphere in British art circles was one of deep suspicion of foreign influence, and a certain smug satisfaction with native talent. The one movement which did have a coherent faith in what it was doing, and which carried over the ideas of the Gothic Revival into the twentieth century, was the Arts and Crafts Movement.

THE ARTS AND CRAFTS MOVEMENT

On the surface the Great Exhibition of 1851 was a great success and showed Britain as the foremost industrial nation in the world. Behind the scenes, however, there was severe criticism of the exhibits; many people involved in the arts and in design, including some of the Exhibition's organizers, were highly critical of the general standard of design. It had become obvious to many that the achievements of the industrial revolution in this country had been paid for at a great price. Not only were workers suffering immense privations and being reduced to the status of machines but the work produced was often shoddy and the designs poor.

The artists and designers who organized themselves, during the 1860s and 1870s, into that peculiarly English social and aesthetical movement called the Arts and Crafts Movement were convinced that something must be done to change society, to change people's attitude to work so that the quality of the work produced could improve. 'All the minor arts were in a state of complete degradation especially in England,' wrote William Morris (1834–96), 'and accordingly in 1861, with the conceited courage of a young man I set myself to reforming all that: and started a sort of firm for producing decorative articles.' The firm was Morris, Marshall, Faulkner and Company and it was to have a profound influence upon English industrial design and interior decoration during the latter part of the nineteenth century.

Charles Ashbee (1863–1942) was the chief organizer of the Arts and Crafts Movement but the founding father was Morris. Pugin and Ruskin's ideas, with their practical application by Morris, influenced whole generations of designers in England and abroad. Morris believed that the faults in modern industrial society lay in the separation of work from joy and of art from craft. Good design demanded a personal knowledge of materials and the techniques involved. The ideal workman was the skilled craftsman and the ideal society was one in which the craftsman, however commonplace the objects he might make, was respected for his work. Art was to be made by the people and for the people as a happiness for the maker and user.

Unlike some of his followers Morris was not a complete enemy of the machine. He realized that machinery could relieve hard drudgery and only criticized the machine when it took work away from the craftsman. The

unfortunate part about the whole theory, and it was the weakness which destroyed the impetus of the movement in the end, was that Morris and his followers found the ideal model for their skilled craftsman in their picture of the medieval workman and his guild. Given the nineteenth century's mania for all things medieval, it was an inevitable progression, but it meant unfortunately that perceptive theories and criticisms of the industrial society of the day dissipated themselves into a rosy romanticism of a medieval Merrie England.

The Arts and Crafts enthusiasts took up socialism and moved to the Cotswolds, reviving rural crafts and founding guilds. The Century Guild was founded by Arthur Mackmurdo in 1882, the Arts Workers' Guild by William Lethaby in 1884, and the Guild of Handicrafts by Charles Ashbee in 1888. It was all delightfully high-minded and very, very middle-class.

It was not altogether impossible to extract the ideas and principles from the romantic nationalism, but no Englishman or woman seems to have been able to do so. Several continental visitors took the ideas home with them and succeeded in setting up projects in their own country. For example, the Deutscher Werkbund was set up in Munich in 1907, and similar foundations were organized in Austria (1910), Switzerland (1913) and Sweden (1910–17). They laid the foundations for the Bauhaus, the most influential design school of the twentieth century. The English Arts and Crafts Movement retreated into rural trades, becoming a nostalgically genteel, folksy affair unable to progress or take in new ideas. Even the closely-related Art Nouveau style was hated and shunned. Morris and Ashbee died frustrated men. 'We have made', wrote Ashbee, 'of a great social movement a narrow and tiresome little aristocracy working with great skill for the very rich.'

The designers themselves were not entirely to blame for this. A great deal of their work had become church work but the Churches in this country failed to offer any help. The Arts and Crafts Movement had taught the Churches to appreciate handmade goods, solid well-made furnishing in 'honest' materials and in a Gothic style; but the Churches failed to make much use of the best exponents of the style. Instead of encouraging the best to explore their latent originality they kept a careful rein on anything made for a church.

William Lethaby (1857–1931), an architect and an influencial teacher of Morris's ideas, only had one commission, a magnificent thatched church. All Saints, Brockhampton-by-Ross. Norman Shaw (1831–1912), who was reckoned to be the pre-eminent architect of the country in the late nineteenth century, and a follower of Morris ideas, only built one church All Saints, Bathcott (1889). Shaw's pupil, Edward Prior (1852–1932), built two, Holy Trinity, Bothenhampton and St Andrew's, Roker. Randall Wells built St (see p. 58 colour plate 18) Edward the Confessor at Kempley for a private patron. These churches are really the sum of the Arts and Crafts churches; apart from them the commis-

8

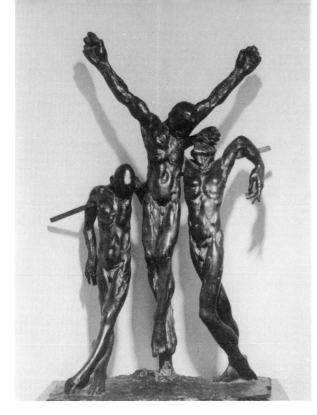

Plate 7
ENZO PLAZZOTTA
Crucifixion and Figures (c.1979), bronze,
The Friary Chapel, Hilfield
*An example of a work of art commissioned
by a religious community,
the Society of St Francis.*

sions were a font here, a reredos there and little else. Admittedly the crafts-men fared a little better. Henry Wilson (1864–1934) had several commissions including the decoration of St Bartholomew's Brighton. But the great furniture designers, Ernest Gimson and the Barnsley brothers, were better known on the continent than for their work here. When one realizes that the Gothic Revival architect, Sir George Gilbert Scott (1839–97), put up seven hundred and thirty buildings, many of them churches, one sees that there was no lack of commissions or money to pay for them, only a preference for the conventional, safe style of the Gothic Revival. Probably the most original design in the competition for the building of Liverpool Anglican cathedral in 1903, came from a team led by Lethaby and Wilson. It was turned down in favour of a Gothic design, one entered by Scott's grandson, Sir Giles Gilbert Scott. (see p. 47 colour plate 4)

Norman Jewson's recollection of the rector of Sapperton seems to be typical of the clerical attitude to these Arts and Crafts designers: 'The rector didn't quite know what to make of them. He couldn't understand anyone who hadn't got to do so, making furniture with his own hands, as Sidney Barnsley did, or any "gentleman" having workshops for furniture making and smith's work like Gimson.' The truth was that English churchmen were hoisted with their own petard. They had welcomed the Arts and Crafts standards, including Ruskin's idea of the importance of 'worthiness' in art and in the artist and the Tractarian assertion that 'a Catholic architect must be a Catholic at heart'. Unlike their Gothic Revival predecessors- men like John Pearson who always received the Holy Communion before designing a church and George Street who gave his office a holiday on church festivals- the generation of Arts and Crafts designers were not churchmen. For the early twentieth century cleric and layman, only believers were worthy to design objects for church purposes; piety came before adventurousness in selecting a designer.

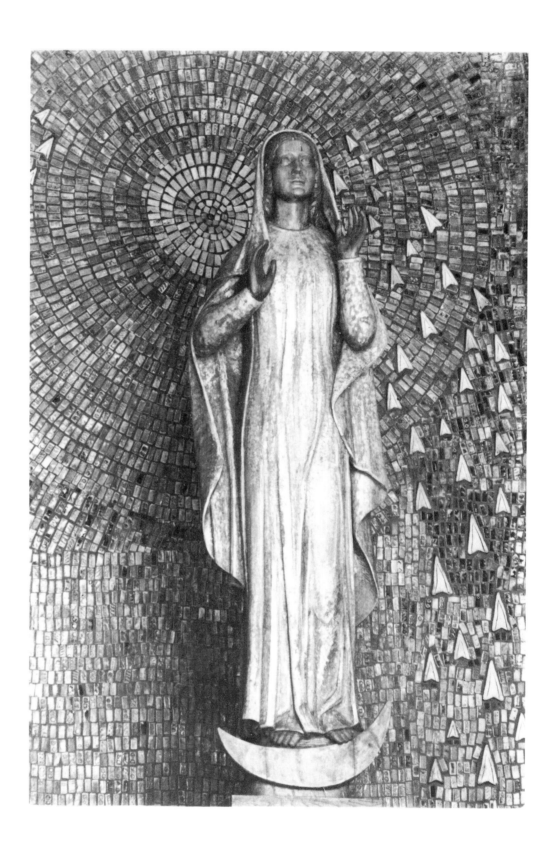

10

There were, however, the beginnings of attempts to bring together interested churchmen and artists and to raise the standards of furnishings and decoration in churches. The guild of St Gregory and St Luke was formed in 1879 for lay Roman Catholics, 'to promote the study of Christian antiquities and of propagating the true principles of Christian Art'. The Church Crafts League was founded in 1899, an Anglican venture 'to infuse new life into the building, decorating and furnishing of churches.' In 1913 Messrs A.R. Mowbray & Company Ltd helped to found the Wareham Guild to organize craftsmen who were working on church furnishings and to make them to approved patterns for the Church of England. These organizations, admirable in their intentions, failed to attract the leaders in art and design. One wonders about the effect of their work when one considers the bitter comment of John Bentley, the architect of Westminster Cathedral, 'The general run of men who are placed in clerical positions of trust, 'he wrote in 1891,' and who are called to sit in judgement on the work we do, belong to the gutter as far as taste is concerned.'

The gap between leading artists and designers and the Churches was now a wide one. Artists had a suspicion that science was replacing religion and clergymen were suspicious of the morals and beliefs of artists. The safest place to buy something with which to decorate a church was at one of the church furnishing firm's shops; everything, from Communion wine to paintings, might be bought under one roof, saving a lot of time and worry. Here were displayed the final expression of Arts and Crafts designs, solid unimaginative pieces of furniture made by second and third generation Arts and Crafts men and women, dull, pious paintings and embroideries in a derivative Gothic style. Today's churches bear witness to the great quantities of objects bought at these shops during the first decades of this century.

Plate 8 *(opposite)*
MICHAEL CLARKE
Virgin of the Glorious Assumption (1960),
agbawood and gold leaf,
the main shrine, Aylesford Priory

3. Merrie, Christian England

A NATIONAL STYLE FOR A NATIONAL CHURCH

IN A LETTER to a colleague, dated 1898, Mandell Creighton, the Bishop of London, wrote, 'The function of the Church of England is to be the Church of free men . . . Its enemy is the Church of Rome; but it ought not to treat its foe with fear but with kindly regard. The Church of Rome is the Church of decadent peoples: it lives only on its past, and has no future. Borrowing from it may be silly, but it is not dangerous, and will pass. The Church of England has before it the conquest of the world . . . The question of the future of the world is the existence of Anglo-Saxon civilization on a religious basis . . .'

It is hard to take such sentiments seriously today but it must be remembered that Creighton, a bishop noted for his statemanship, efficiency and tact, was only expressing views that many English people of the time sincerely believed about the Church of England, the Roman Catholic Church and civilization in general. During the nineteenth century Britain had grown in prosperity and influence as she had never grown before. English people felt proud to be British and proud of their British institutions, the empire and the monarchy, the established Church and the mother of Parliaments; each in a sense represented all the others.

The majority of Englishmen and women took it for granted that the Church of England was the national Church and the Church of the empire, and its visual symbol was a Gothic building. The popular acceptance of Gothic Revival architecture was partly religious and partly patriotic. It had come to be, as Sir Kenneth Clark pointed out in his book on the Gothic Revival, 'the standard Anglican form; so that if, in some glaring I talian street, we see a small Gothic building in the "decorated" style, we say, "English church", without hesitation.'

However, not all members of the Church of England were happy with this image of their Church. The Anglo-Catholic party, the inheritors of the Tractarian tradition, were openly critical of what they considered the narrow parochialism attached to the Gothic image.

As good Tractarians they believed in a world-wide Catholicism, and emphasized their belief in being part of the one Great Church. Many of them replaced the Gothic image with a Baroque one, the latter being the one style common to all Western Europe before the schisms of the Reformation. The Baroque style was a visual gesture towards unity, looking particularly

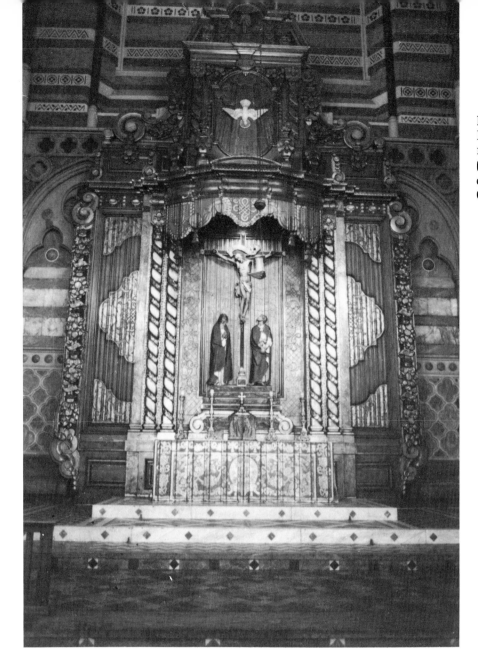

Plate 9
MARTIN TRAVERS
reredos and high altar
(1926), St Augustine
of Canterbury, (1926)
Queen's Gate, London

towards the Church of Rome. Ecclesiastically speaking the Anglo-Catholics were many years ahead of their time.

One of the main organs of Anglo-Catholics was the Society of St Peter and St Paul — founded 1911 — a publishing and furnishing house which employed designers and craftsmen to make furnishings in the approved Baroque style. In 1920 their chief designer was Martin Travers (1886–1948). His finest work was undoubtedly the graphic work for the society's books and when he ventured into interior decorating he adopted Spanish and Latin-American models, using a lot of plaster and gilt. One of his more extravagant projects was the high altar reredos for St Augustine's, Queen's Gate, in London, which he erected with the help of his students from the Royal College of Art in 1926. This reredos is remarkable for its stylized flat detail and subtle gilt patina. It was Travers's furnishings which resulted in the church being known to the wits as 'The Essoldo, Queen's Gate.'

13

The other Churches in England did not appear to be concerned about the link in people's minds between the Church of England, nationalism and Gothic style. One suspects it merely confirmed their belief that the Church of England was totally Erastian after all. Ecumenical relations were not, in the 1910s and 1920s, very close. The Free Churches had inherited, from the spate of Noncomformist building in the 1850s, buildings in a small, domesticated, brick version of Gothic Revival and contented themselves with increasing the dark pinewood furniture inside.

The Roman Catholics followed a different policy. Cardinal Herbert Vaughan (1832–1903). Archbishop of Westminster, was determined to build a principal Roman Catholic cathedral in London. He considered the time was ripe for this; it was important for British Roman Catholics to represent their cosmopolitan faith in a way fitting for a London which was becoming the new commercial and financial centre of the world. In 1894 he chose John Francis Bentley (1839–1902) a leading Roman Catholic architect, to build a cathedral on the site of the Old Middlesex County Prison, on Tothill Fields in Westminster. The foundation stone was laid in 1895 and by 1903 the building was completed. Vaughan realized that his building could not compete architecturally with nearby Westminster Abbey and he favoured an Italian style of architecture. Bentley argued for a Byzantine style and the result was a free version of a Byzantine building with an Italianate tower and portico. It was the beginning of a revival of interest in Byzantine design and it set a fashion for building Mediterranean-type Roman churches in this country. In any English town one could tell at a glance to which Communion a particular church belonged; a Gothic tower or spire meant 'C of E' while an Italianate campanile meant 'RC', except of course that the Anglo-Catholics confused the whole neat distinction by building Italian-looking churches and then putting up notices announcing that they were 'In communion with the See of Canterbury.'

ECCLESIASTICAL ANTIQUARIANISM

The Christian religion is founded upon the interpretation of certain historical events which happened nearly two thousand years ago in a remote eastern part of the Roman Empire. To be true to its principles the Christian Church has constantly to measure itself against the community which was made up of the close friends of the Messiah Jesus, not only to confirm its own beliefs but to refresh and stimulate its worship and its daily devotion.

Several events which happened in the nineteenth century awoke English Christians to the importance of history to their religion. One was the Oxford Movement in the Church of England and the other was the desire among the English Roman Catholic hierarchy to bring the practices and ornaments used in their churches under stricter control. Both appealed to history to support

their ideas and both unwittingly produced an antiquarian attitude of mind, a preoccupation with the ecclesiastical past to the detriment of the present.

When he was Bishop of Salford, Herbert Vaughan issued his Directions of 1882. His object was to standardize the ornaments and liturgical practices in the Roman Catholic churches within his diocese so that there was a greater uniformity with other parts of that Church. When he was made Cardinal Archbishop of Westminster his Directions were used over the whole country. The Directions went into great detail about what was, and what was not, permitted and were based upon the eighteenth century decrees of Pope Benedict XIV. In visual terms they meant a return to a Renaissance model. John Bentley had provided the style of architecture with his Byzantine-Italianate cathedral and the Roman churches of the Renaissance provided the standard interiors. So, Pugin's principles for a Christian church were forgotten by his own people; there was to be no new building in the Gothic style. Another style from the past was to be used. To be correct and valid, one did not need theology expressed in architecture and art, one needed to study the proper books, to follow the antique details.

The leaders of the Oxford Movement, university dons like John Keble, John Henry Newman and Edward Pusey, taught the Church of England to see its history and traditions as one continuous stream deriving from the Church of apostolic times. There was, in the 1840s, a general dissatisfaction with the conduct of the Church during the past hundred years; devotion seemed arid, liturgy seemed plain and dull, and there had been considerable neglect of the fabric of churches. Enthusiastic Tractarian parish clergy were soon renovating their decaying medieval churches, removing Georgian additions and generally attempting to put things back as they supposed the original worshippers had intended them to be.

It was, however, one thing to encourage Anglicans to rediscover their past but quite another thing to provide accurate details of what that past was really like. There was no common agreement about medieval liturgy, ceremonial or devotion, nor were the rubrics on the Book of Common Prayer of 1662 particularly clear about what was permitted and what was not. The Church hierarchy was not particularly enthusiastic about the glories of the past nor happy about the experiments it came across. Its various attempts to restore some kind of authority and order by resorting to the courts of ecclesiastical law only made matters worse. A parish priest, hauled up before a Consistory Court for wearing eucharistic vestments might be arraigned for illegal conduct but he soon became a martyr for a cause. No church lawyer, bishop or priest could agree what was or what was not allowed ceremonially in the rubrics of the Book of Common Prayer or in the Canons. Some hardly cared in any case; for many Victorian Anglicans the past, and particularly the medieval past, was a door to a Merrie, Christian and beautiful England, and the key was antiquarianism.

In 1897, the Alcuin Club was formed with the object of encouraging the practical study of ceremonial and church furnishing in accordance with the Book of Common Prayer. Its publications, printed on handmade paper, only reached a limited circle of enthusiasts. One man, however, who did more to restore decency and order in Anglican worship of the time was the Reverend Percy Dearmer, (1867–1936) who became vicar of St Mary's, Primrose Hill, in 1900.

In 1899 he wrote *The Parson's Handbook* in which he criticized the 'lamentable confusion, lawlessness and vulgarity' which affected so many church services. He set out to show what was legally and historically correct ceremonial for the Church of England and what was of practical use for a parish church in its proclamation of the Christian gospel. He abominated pious clutter and demanded that church interiors should be beautiful, and simply beautiful. The Handbook was legalistic in tone, nationalistic and strongly antiquarian in inclination; so popular that it went into many editions soon after it appeared.

Its influence was not only national but stretched to even the remote parts of the British Empire, wherever there was an Anglican church; and it did a great deal to restrict amateurishness and private judgement in church decoration. However, Dearmer created a beautiful ceremonial, the so-called 'English Use' — a work of art in its own right — but although he appealed to the past, it was questionable whether the Use ever existed at all. It was an antiquarian ceremonial, nicknamed 'British Museum Religion', concerning itself with the past above all else.

There is no doubt of the achievements of Percy Dearmer but it is very interesting to consider what he did *not* do. He lectured and wrote a great deal about the visual arts in church, but it appears he did very little for it. He entertained art students at his house in Chelsea, he was a near neighbour to several artists and he often complained that the contemporary Church neglected artists of the day; but there is no record that he ever got to know any of them or commissioned a work of art for any of the churches with which he was involved. While he was vicar of St Mary's, Primrose Hill, he renovated the inside and made it a leading example of his own theories. But no painter or sculptor was ever commissioned to make anything for it. It was as though the beauty of the past so overwhelmed him that he could offer others nothing from the present. The impression he gave, like many of the cathedral guide-books sold today, was that in comparison with the past, there was no new art worth talking about. He wrote, 'great art flourished between the twelfth and seventeenth century,' and, 'somehow modern civilization has spoilt the world — has taken from it that beauty which God gives it: somehow the religious world has acquiesced in this wrong ... the Church in the nineteenth century has produced little or nothing of high quality.' He wrote that in 1924. One can only presume that the Pre-Raphaelites and the work of

the Arts and Crafts people did not come up to his standard of high quality. But had he not heard of Cézanne and the Post-Impressionist exhibitions organized by Roger Fry in London in 1910 and 1912? Had he not heard of Sir Frank Brangwyn's great mosaic in St Aidan's, Leeds, of 1916? Had he never come across a new generation of religious artists, the sculptor, Eric Gill, at that time in his retreat at Ditchling in Sussex, or the young Stanley Spencer with seven religious paintings to his credit and making a name for himself in London? We do not know; there is a strange isolation about Dearmer and his work. *(see p. 46 colour plate 2)*

Perhaps the best illustration of the antiquarian spirit at work in the Church is the career of Sir John Ninian Comper (1864–1960). Articled to the Victorian architect, George Bodley, he specialized in church restoration, building and furnishing, and set up his own practice in London in 1881. He was a highly original and learned architect who during his long life believed implicitly in the Gothic style. 'Gothic architecture for churches today, "he wrote in 1934," is still capable of a real and living development.' There is much in his work that anticipated the ideas of the modern liturgical revival movement. He built free standing altars in many of his churches and believed that the functional purpose of a church, its liturgical fittings, were of more importance than the actual building. 'I build', he said, 'from the altar outwards.' *(see p. 45 colour plate 1)*

However original some of his ideas were, he remained at heart an antiquarian. Comper came to realize that the highest expression of beauty could be achieved only by the inclusion of various styles and not by excluding them. He was convinced that the sources of beauty were universal. One might go, he believed, anywhere in the world and, on finding something of beauty, discover common underlying aspects with other beautiful objects. He believed that unity in design might be achieved by the inclusion of all styles and periods. For example, his church of St Mary in Wellingborough is in the perpendicular style, but the columns have the Greek slight convex curve, called an entasis, and the same fluting as those in the Parthenon. For Comper, beauty was basically one because it was an absolute value in itself, a revelation of the image of God.

Comper was knighted in 1950 and died still working at the age of ninety -six. He upheld to the end Pugin's idea that Christian architecture ought to express a Christian doctrine.

4. The patrons

THE NEW CATHEDRALS

Comper died in 1960. It was the end of an era for art in English churches and the beginning of something new. Two years later Coventry Cathedral was consecrated and it was the first real attempt to build a twentieth century cathedral in a twentieth century style using modern materials and techniques, and also to include within it the works of art of many artists and designers.

In 1940 the medieval cathedral was hit by an incendiary bomb and burned down. At the instigation of the Bishop of Coventry, Neville Gorton, it was decided to build a new one among the ashes of the old as an act of faith and as part of the reconstruction of Britain after the devastations of the Second World War. An architectural competition was held in 1951 and initially there was a stipulation in the regulations for a Gothic design, but this was withdrawn. However, many neo-Gothic drawings were submitted and the assessors expressed their disappointment with the range and quality of the drawings. They finally chose a modern design by Sir Basil Spence. The

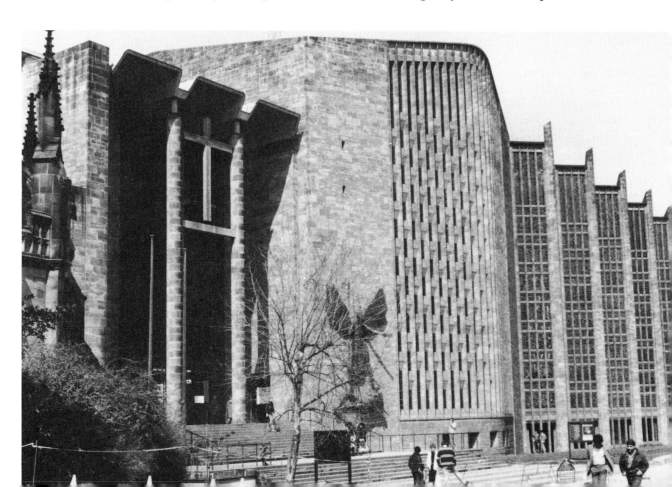

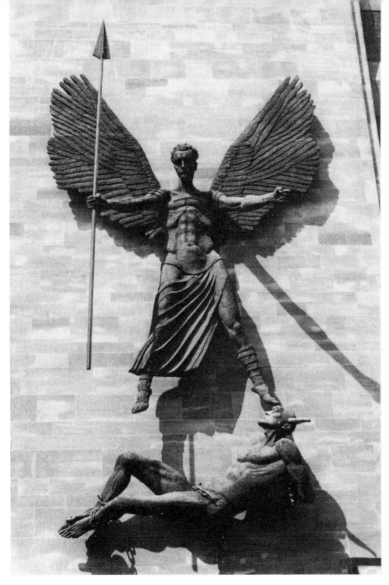

Plate 10 (opposite)
Sir BASIL SPENCE
Coventry Cathedral (1956–62),
the West entrance
with part of the old Gothic cathedral
on the left.

Plate 11
Sir JACOB EPSTEIN
St Michael and the Devil (1959),
Coventry Cathedral

schedule of requirements included a message from the Bishop and the Provost of Coventry. 'The Cathedral is to speak to us and to generations to come of the Majesty, the Eternity and the Glory of God . . . (and) witness to the central dogmatic truths of the Christian faith . . . The Cathedral should be built to enshrine an altar . . . a people's altar.' It was a remarkably modern statement, modern because, before this, no church committee building a cathedral had ever seen the need to explain what a cathedral church was for; it was assumed everyone would know.

Spence believed that architecture should grow out of the conditions of the time and not copy past styles. Continuity, unity, permanence and vitality were the necessary ingredients for the building he wished to erect. He wanted the cathedral to be, he said, 'like a plain jewel-casket with many jewels inside,' (*Phoenix at Coventry*, G. Bles, London, 1962) to turn the casual visitor into a worshipper.

To create his 'jewels' Spence turned to some of the foremost British artists of the time, to Graham Sutherland (1903–80) for the design of the great East end tapestry, to Jacob Epstein (1880–1959) and Elizabeth Frink (1930–) for sculpture. Stained and engraved glass was to be an important part of the building

19

and the Coventry commission was probably the largest single one in the whole history of the craft. John Piper (1903–) was invited to design the windows for the baptistry, and Lawrence Lee, a pupil of Martin Travers, with the Glass Department of the Royal College of Art, was commissioned to make the nave windows.

There was a nation-wide interest in the scheme and it aroused a great deal of controversy and opposition. Many doubted whether it was money well spent. Did we need a new cathedral in England when money and materials were in such short supply? Should these not go on housing projects? The authorities disagreed, there was a psychological, as well as a spiritual, factor involved; Britain needed a symbol of its reconstruction and Coventry cathedral was just that. The British public was never happy with the abstract and distorted qualities in twentieth century art. The bewilderment and opposition which had focused upon Reg Butler's abstract sculpture 'The Unknown Political Prisoner' in 1953 was now turned, with even more force, upon the proposed works of art for Coventry. It was one thing for modern art to be displayed in galleries where the initiated few might go and see them, but quite another thing to have it displayed in a cathedral. Many people in this country were horrified at the departure of religious architecture and art from old and loved styles. For many British Christians no artefact or institution was safe from desecration any more, whether it was the Bible — the New English Bible came out in 1961 — or the liturgy or the buildings. Even conventional concepts of God himself were under attack; *Honest to God*, by John Robinson, came out in 1963.

Spence was deluged with letters from people complaining about this modern work. Even Coventry City Council refused to have anything to do with 'that concrete monstrosity' as they called it. The Architectural Review of January 1952 carried an article which was very critical of the whole scheme. The Royal Fine Arts Commission, asked to give its opinion, approved the plans but in guarded terms. Spence, however, with great tact, diplomacy and determination, and the support of the bishop, continued and maintained the support of the Cathedral Council and Reconstruction Committee. By the time Coventry Cathedral was completed the professional journals and the critics were on his side and were acclaiming that the building, with some reservations, was a success.

A leading article in *The Times* of 23 March 1962, called it a great achievement, and Spence's attempt to weave together all, what it called, the decorative pieces into a whole it found most impressive. The reference to 'decorative pieces' — a rather disparaging one apparently — is interesting. It calls into question whether the works of art should be just that or more besides. Is it enough to say that works of art decorate a church? Admittedly, Spence expected the works to be 'jewels' and it is the function of jewels to decorate a body, but surely he, or the bishop in his message, expected them to be far

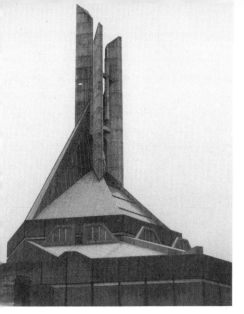

more. They are 'to speak of the Majesty, the Eternity and the Glory of God' and pieces which decorate fall far short of fulfilling that ideal.

At the cathedral entrance people cannot fail to notice the message of Epstein's 'St Michael and the Devil'. Being far more than just decoration it proclaims the triumph of good over evil. Once inside the building the Christian message, unfortunately, becomes blurred. The tapestry of 'Christ in Glory' overwhelms, by its sheer size, the place symbolizing the earthly triumph of good over evil, the altar. For many people, Sutherland's tapestry is a majestic and exciting image of Christ. It demonstrates majesty, but it is an overwhelming majesty, and one wonders whether that is a proper attribute of Jesus.

However, with all its unanswered questions and admitted reservations, Coventry Cathedral had made English people realize that modern art had come to stay in their churches. It is not only a symbol of the reconstruction of a war-scarred Britain but also a symbol of new things happening in the Churches. The cathedrals which were built after Coventry were able to benefit from its experience.

The Metropolitan Cathedral of Christ the King in Liverpool had a similar history of planning and of intentions. The Church authorities wanted a 'visual expression of man's belief in God' and a building 'to enshrine the altar of sacrifice'. They also wished the structure to be of a broad architectural framework within which the other arts could obtain significant expression. The design by Sir Edwin Lutyens, of 1934, had never been finished. Only the crypt had been built. In 1959 the cathedral authorities held an architectural competition for a new design. They stipulated no particular style, only insisting that Lutyen's crypt should be incorporated in any new design. The competition was won by Sir Frederick Gibbard. The building started in that year and was completed in 1967. As at Coventry, the work of many artists have been included, in the cathedral, including that of local Liverpool artists. Elizabeth Frink, John Piper, Patrick Reyntiens, Ceri Richards were all, with many others, invited to contribute.

The latest cathedral to be built is the Roman Catholic cathedral of St Peter and St Paul in Clifton. It has been described as 'the ecclesiastical bargain of

Plate 12 (above, left) PERCY THOMAS PARTNERSHIP Clifton Cathedral Tower (1970–73)

Plate 13 (above, right) WILLIAM MITCHELL Station of the Cross (1970), fibreglass and concrete.

1970.' Costing only six hundred thousand pounds it took three years to build and was consecrated in 1973. On an awkwardly shaped site the architects, Percy Thomas Partnership, solved the numerous problems by designing a diamond-shaped building, seating a thousand people; the space is so well designed that no worshipper is more than forty-five feet away from the celebrant. It is a very functional building because liturgy has determined its form. The two foci are the altar and the font. If it is not a beautiful building, at least it pleases the eye because it does admirably what it is supposed to do: to be a structure to cover a liturgy. The works of art inside are few and functional and very effective. William Mitchell's Stations of the Cross, in concrete and fibre glass, are set in the inside walls of the building and colour is given to the inside by Henry Haig's stained glass baptistry windows. Nothing distracts the attention away from the liturgy; rather all things inside enhance it. One gets the impression that there has been a gradual learning of lessons from the building of these three cathedrals, and Clifton is the result. Perhaps the best comment on it comes anonymously from a local worshipper: 'There aren't many modern buildings I'd like to see standing for three hundred years, but I know that this will warm my heart as well as my soul'.

THE INDIVIDUALS

It would be quite incorrect to suggest that there was no twentieth century art to be found in English churches before the building of Coventry Cathedral. Equally it would be wrong to say that no church up to that time was built in anything but a style copied from the past. But the instances are very few and unconnected.

There are churches built by Francis X. Velarde. St Gabriel's Blackburn (1932), St Matthew's, Liverpool and St Monica's, Bootle (1936) are all decorated inside in an Art Deco style. The chromium-plated altar rails are reminiscent of the stair handrails of the great cinema palaces of the 1930s. (How wonderful it must have been to find that one's Saturday night out with the Holly-

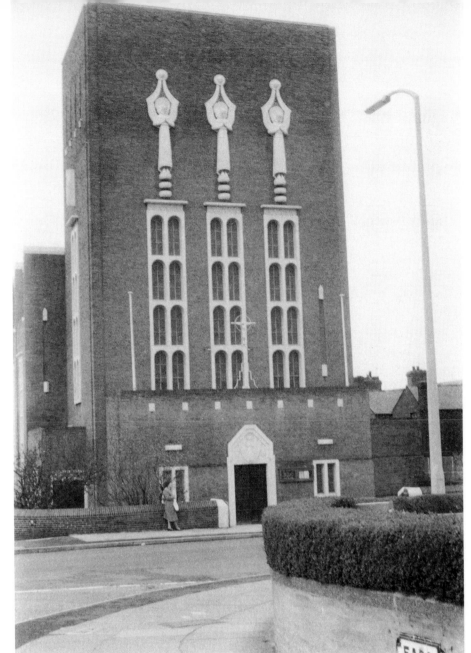

Plate 15
FRANCIS VELARDE
St Monica, West front, (1936),
Bootle

wood stars was skilfully extended into one's worship of God Almighty on Sunday mornings. What incarnational theology!) There is also the Church of the First Martyrs in Bradford (1935), an octagonal building, Eric Gill's church of St Peter at Gorleston-on-Sea (1939), Comper's church of St Philip, Cosham, (1938), all with free-standing altars anticipating the liturgical reforms of the 1960s. There is Cachemaille-Day's church of St Michael and All Angels, Wythenshaw (1937) and John Keble Church, Mill Hill (1936). But these are the exceptions to the general church building between the wars. They are the inspiration of individual men, either a parish priest or an architect.

It is the individual who between the wars was responsible for introducing modern art in the Church. Probably the earliest example of individual patronage is the remarkable Fr Bernard Walke who, in 1920, invited a whole colony of artists from Newlyn to paint the lives of the Cornish saints in his little country church at St Hilary near Penzance. On one of his excursions to *(see p. 75 colour plates 37 & 38)*

London he found himself in an argument about religion in a Bloomsbury restaurant with the art critic, Roger Fry. It is to the credit of Fr Walke that he did not leave the restaurant until he had a promise of a painting of St Francis by Fry, one which now hangs in the church.

One other isolated example is that of Canon James Hetherington, Roman Catholic parish priest of St Aidan's, East Acton. He commissioned several works of art for his new church which was built in 1961. Over the high altar is a crucifixion by Graham Sutherland, there are two triptychs by Roy de Maistre, as well as works by Adam Kossowski, Philip and Michael Clark, Arthur Fleischmann and Pierre Fourmaintraux.

The two men who probably had the greatest influence upon changing attitudes to modern art in churches were George Bell, Bishop of Chichester from 1929 to 1958, and Walter Hussey, Dean of Chichester from 1955 to 1977. George Bell was a man of wide interests and activities. His interest in the arts led him to promote religious drama, to encourage T.S. Eliot, Dorothy Sayers and Christopher Fry to write for the Church, and to attempt to create situations whereby living artists could be brought to the attention of the clergy and parishioners. In 1941 he founded the Sussex Churches Arts Council and organized a loan scheme for paintings to be placed in churches. Perhaps his greatest contribution was to attack the Ruskinian idea of the worthiness of the artist. This attitude had probably done more than anything to alienate artists from institutional Christianity. Bell, by his preaching and writing and his judgements in ecclesiastical courts, did much to alter this view. He was concerned to bridge the gulf between the Church and the artist, not, even in the dark wartime days of the early 1940s, as some kind of morale booster, but rather because he believed that a re-association of the Church and the arts was an effective protection against barbarism, whether that barbarism was Nazism, materialism or any other threat to civilization.

He was concerned about the spiritual poverty he saw in contemporary society and he believed that the visual arts had an ability to teach about Christianity that few other disciplines had. The artist could, he said, 'help children and the ordinary man see the meaning of Christ's life today.'

(see p. 50
colour plate 8)
He was the first to admit that he had no special knowledge of the arts, but he did possess a deep admiration for artists. His personal patronage in several churches in his diocese show more enthusiasm than a critical eye; many of the works executed for him are very mediocre as, for example the murals in St Elizabeth, Eastbourne. He seemed, as a good pastor, more interested in the artist than in his art.

Dr Walter Hussey was vicar of St Matthew's, Northampton, from 1937 until 1955. He is a priest with far more ability than Bell in choosing artists and persuading them to accept commissions. The parish had an annual arts' festival during St Matthewstide, which during the 1940s attracted a very remarkable number of first class musicians and artists. Hussey had a gift for

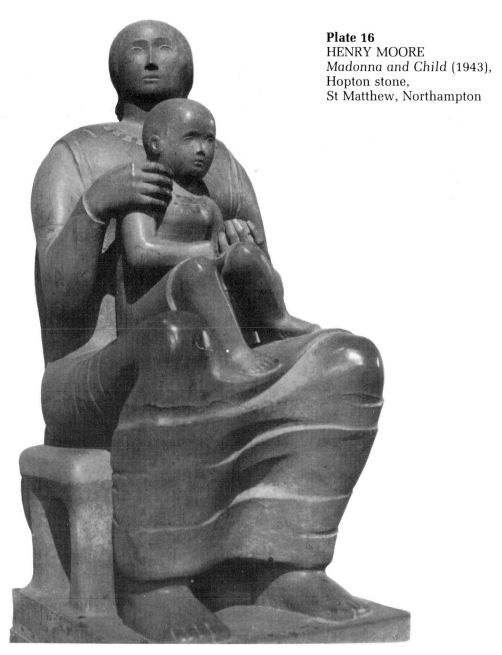

spotting young talent before the fees were too much for parish resources. Henry Moore, Graham Sutherland, Benjamin Britten, Peter Pears, and W.H. Auden were among those who contributed to the various festivals in the 1940s. Moore's 'Madonna and Child' (1944) in Hopton stone, created a great sensation and people were shocked by its solemn novelty; they had seen nothing like it in church before. Its fame was firmly established by being singled out by that famous enemy of modern art, Sir Alfred Munnings PRA. In his presidential speech of 1949 he referred to a 'Madonna and Child in a church in Northampton. My horses may all be wrong — we may be all wrong — but I'm damned sure that isn't right.' Dr Hussey survived the assaults

because he took the sensible precaution of getting the unanimous support of his staff and church council before any commissions were confirmed. This was just as well because he would have had little help from his superiors. It is reported by his curate of the time that, at the dedication service for the statue, the Bishop of Peterborough could hardly bear to look at Moore's work, as though he were frightened of it!

In 1955, Dr Hussey became Dean of Chichester and continued his aptitude for encouraging artists. He was responsible for inviting John Piper to make hangings to go behind the high altar, for Sutherland's painting, 'Noli Me Tangere' in a side chapel and, on his retirement, the window, 'O Praise God in his holiness', by Marc Chagall.

THE SOCIETIES

The religious communities in the country, both Anglican and Roman Catholic, have taken a serious interest in the visual arts since the 1940s. They have frequently commissioned artists to make works for them and also have encouraged the professional artists among their own members to continue their work as part of their religious vocation.

Without going into great detail about their contribution to the arts, mention must be made of one community, the Carmelite Priory at Aylesford. It was refounded in 1949 on the site of their pre-Reformation mother house. Under the leadership of Fr Malachy Lynch, the community began restoring the fabric of the buildings and building several new chapels. Fr Lynch was introduced to a Polish refugee painter, Adam Kossowski, and invited him to paint a series of illustrations for the Mysteries of the Rosary Way. Thus began his remarkable series of ceramic reliefs which can be seen on the walls and altars of the chapels at the Priory.

The lay societies for artists which sprang up during the early years of the century have either changed or disappeared. The Anglican Church Crafts League faded away some time after the Second World War, and the Guild of Catholic Artists and Craftsmen changed its name to the Society of Catholic Artists in 1964. It still meets and has largely superseded other smaller Roman Catholic groups. The Societé Internationale des Artistes Chrétiens, which was founded in Rheims in 1951, has a British branch and includes Christian members from all the arts.

Official recognition of works of art in churches has been slow in coming. In the Church of England, mainly through the pioneer work of Dr Francis Eeles, Diocesan Advisory Committees have been set up and also the national Council for the Care for Churches. These bodies act as advisory groups recommending artists for commissions and offering advice about what is, and what is not, suitable for including in a church. The Council for the Care of Churches co-operates with the (Roman Catholic) Art and Architecture

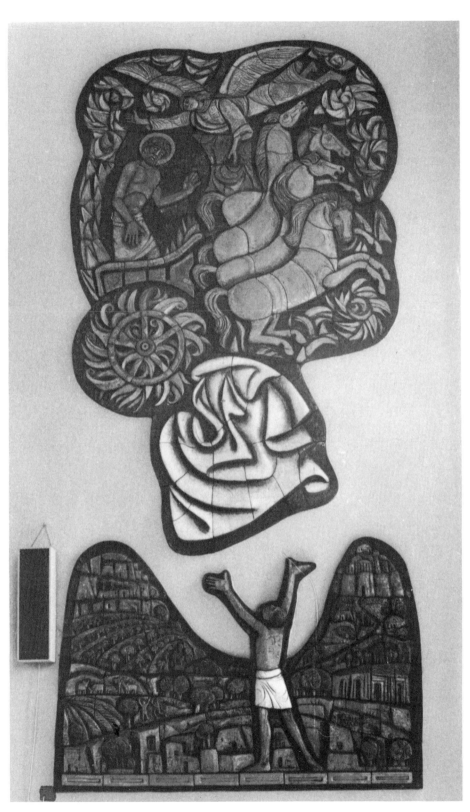

Plate 17
ADAM KOSSOWSKI
The Vision of Elias,
ceramic tiles,
St Joseph's chapel,
Aylesford Priory

Department of the Liturgical Commission in organizing annual conferences for interested artists from all denominations and disciplines.

(see p. 73
colour plate 35) It would be pleasant to record that the Roman Catholic Church in England had encouraged and made full use of one of their greatest twentieth century religious artists, Eric Gill the sculptor, but unfortunately this cannot be said to be the case. Independent in thought, eccentric in his habits, he was very much his own kind of Catholic, socialist and writer, at a time when these qualities of independence were not popular in his Church. He was commissioned to carve the Stations of the Cross for Westminster Cathedral in 1914 and they are among his finest work. He felt honoured to be asked to do them but it was not a happy time for him. He loathed the building, inside and out, growled at people who came to see him working, and complained incessantly.

It is only fair to add that the other great English religious artist of the twentieth century, Sir Stanley Spencer, was no easier to fit into the respectable atmosphere of the Church of England of the 1930s and 1940s. His exaggerated reputation as the 'satyr of Cookham' clouded people's judgement and the importance of his religious painting for the Church. The record, is however, somewhat redeemed by the care and sympathy shown to him when, lonely and dying, the vicar of Cookham, Michael Westropp, and his wife, nursed him in their vicarage. A life-long dream of Spencer's was fulfilled in 1958, the year before he died, when an exhibition of his religious paintings was held in his beloved Cookham church.

There can be no doubt that church patronage of the arts in this country has improved very much since the Second World War. An attitude of co-operation has appeared between clergy and artists which did not seem to exist before. The clergy may still find difficulties in understanding the ways of an artist, but at least many now appear to be making the effort to do so. How much this change is due to the influence of the individuals who have been mentioned and the example of the new cathedrals can never really be assessed, but one can guess that it is considerable.

It is important to realize what has happened in art education since the war. There are now more, and better trained, professional artists and designers in Britain than ever before. The standard of teaching in art colleges has risen immeasurably and this is largely due to the work of college principals, and in particular the work of Sir Robin Darwin at the Royal College of Art. Today there is no guarantee that employing a well-known name will necessarily ensure workmanship of a standard far higher than that of the local artist. In fact the local man or woman may have the advantage of knowing local colour and local conditions and be able to use it effectively in his or her work.

As an illustration of this general improvement in standards there is an interesting example from two churches on the outskirts of Eastbourne. In 1941, Bishop George Bell was determined that the war, with its shortages and

difficulties, should not hinder any commissions for churches in his diocese. The architect, Sir Charles Reilly, suggested an interesting idea to Bell, that the artist, Duncan Grant, be invited to paint some murals in the little church of St Michael and All Angels, at Berwick on the Sussex Downs. Grant and his wife, Vanessa Bell, two well-known members of the Bloomsbury Group, lived nearby. They both agreed to the idea and drew up a series of drawings. There was to be a 'Christ in Glory' over the chancel, a crucifix to be painted on the west wall and scenes of the Annunciation and the Nativity on the walls of the nave. With the help and encouragement of various influential friends of Sir Charles, including Lord Maynard Keynes and the art historian, Sir Kenneth Clark, the money was found, the legal preliminaries overcome and the Grants began their work, completing it in 1943.

*see p. 48
colour plate* 5)

The project, as George Bell probably intended it would, caused quite a stir of interest and some surprise; members of the Bloomsbury Group were not known for their interest in the Church. Bell, however, probably saw the project as an excellent occasion for artists and church people to come together. Sir John Rothenstein, the writer and painter, came down to see the finished work and pronounced them, 'among the best paintings to be made in church or chapel in England during the present century.' In retrospect, one sees that this was not saying very much at all. In spite of the famous names involved and all the fuss, the murals look today — except perhaps for the crucific — very mediocre work, marred by crude drawing, sentimental and of poor composition.

On the other side of Eastbourne there is a small, new Roman Catholic church, Christ the King at Langney. In 1968 a local artist, Tom Hill, painted a series of Stations of the Cross for the price of the materials.
Since then he has left the country and nothing more is known of him or his work. No great interest has been shown in these paintings and very few people beyond the parishioners know they are there. However, the church now possesses a striking series of paintings executed in a highly professional way. They are disturbing in just the way the Stations of the Cross should be, yet they are full of local colour without being sentimental. Worshippers can identify with them, they can see the suffering without wallowing in morbidity. They are a fine example of what a local artist can do for a church.

(*see p. 49
colour plate* 7)

5. Art and Christian worship

There are two fundamental influences upon Christian worship which are often overlooked by those who practise it. The first is that human beings worship through their senses and the second is that the surroundings to worship will inevitably affect the participant.

Worship can be defined as man's response to God. It is a response that can be expressed both socially and individually and it begins in a man's consciousness that there exists a Being outside himself who transcends his whole being. Worship also exists in a man's relationship with his whole environment, in which he is constantly reminded of his own insufficiency. Men and women cannot but worship. If they do not worship God they will worship something else, something less worthy of that worship; and even then there is a chance that some trace of the worship of God will remain.

The senses are a human being's faculty of perception and consist in those senses called the bodily senses, of sight, smell, hearing, touch and taste, and also in some less easily definable faculties which are known as the 'inner senses'. It may seem possible for a person to worship entirely without the use of his senses — to shut his eyes, to remain still and silent — but without some kind of inner sense-perception of God it could hardly be called worship; without any kind of perception going on a human being would either be unconscious or dead. For most worshippers, however, one or more of the bodily senses is in operation, and with it some kind of art form is going to be involved. In fact it can be said that there is no worship without the use of some kind of art. Even those believers who keep their worship at a very plain and simple level employ some art in their worship. For example, the American Shaker community, a breakaway group from the Quaker movement and strong advocates of the simple life, held their services in very plain meeting houses, but they danced and they sang their hymns. The Gaelic-speaking Free Prebyterians from the Outer Hebrides, while refusing to use organs or musical instruments of any kind in their services, have their own distinctive form of singing the psalms. Worship, it would appear, is bound up not only with the senses but also with art.

The ordinary worshipper cannot shut out the influence his environment will make upon him. If he tries to do this, it will mean forcing his concentration, and the inevitable loss of the relaxation of the body which is a necessary condition of the body for that activity. If the whole idea of worship is seen as an activity based upon the screwing up of concentration and the avoidance of distractions — one in which the worshipper crouches down, tightly shuts

his eyes and clasps his hands — the whole effort is bound to fail. It becomes not worship but merely an exercise in spiritual method. It is more important to admit the existence of distractions and turn them into positive prayer than to ignore them;, to absorb the environment into one's awareness and use it as a pointer to God. That, of course, does depend upon the environment, whether it will help or hinder. The thing the environment will not do is remain psychologically neutral.

A church interior can help or hinder worship. Its overwhelming effect upon people's worship will be similar to what it looks like. If a church interior looks overwhelmingly something to do with the past and very little to do with the present, the worship inside will be affected accordingly. A new church building on a housing estate which looks just like another local amenity will breed a similar kind of worship, and the Christians inside will have the utmost difficulty in experiencing the eternity, the mystery and the love of God. 'The very majesty and holiness of the place,' wrote the sixteenth century Anglican divine, Richard Hooker, 'where God is worshipped, hath in regard of us great virtue, force, and efficacy, for that it serveth as a sensible help to stir up devotion, and in that respect no doubt bettereth even our holiest and best actions of this kind.'

It can be argued that Christians do not need to concentrate on such things; that they ought not to worry about material objects in their churches or to concern themselves with them since this brings the danger that their worship may be diverted from God and on to material things. The answer to that is that it depends upon the objects involved. If they are such that they demand to be worshipped then the Christians are in great danger; but if the objects are of such a nature that they point past themselves to God then it is fitting they be found inside a church.

The function of a work of art in church is just this, to point past the material to God Almighty in any way that is in accordance with its nature. The supreme example of a work of art fulfilling this function is the icon which, by its style and tradition, and by its method and the intention of its creation, is so designed that it can take the viewer beyond the visual image to experience a glimpse of the nature of God. Other works of art may achieve this to a lesser degree but their function is the same.

ART AND THE INCARNATION

'Christ was made man that we might be made God,' said bishop Athanasius (c.296–373), 'and he manifested himself by a body that we might receive the idea of the unseen Father.' One of the great interests of twentieth century Christians has been in the doctrine of the Incarnation of Jesus, the belief that God the Son was born in human form and that humanity has never been the same again; that Christians worship a God/man who is like us and yet divine, and who suffers not only for us but with us. It is not only Christian scholars who have been interested in this belief, twentieth century artists have also

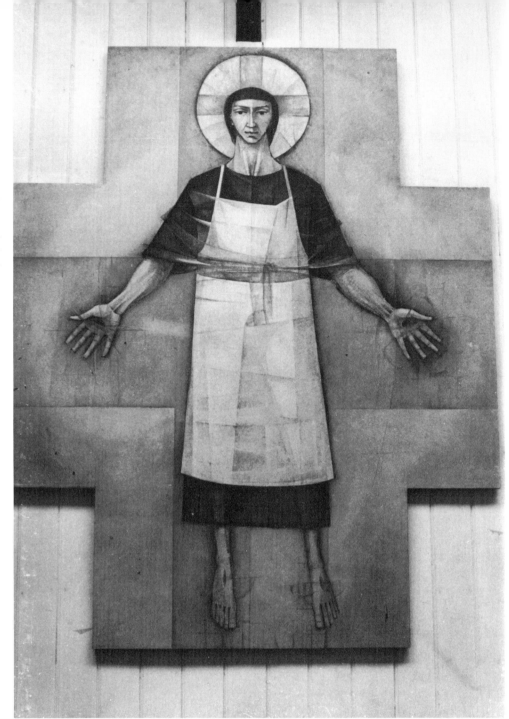

Plate 18
JOHN HAYWARD
Christ the Worker (1965),
painting on wood,
Southwark Ordination
Course Conference
Centre chapel,
Bletchingley.
*An example of how
the twentieth century
has perceived Christ.*

incorporated the doctrine in their work. The remarkable thing is that there
has been little contact between the two groups. In 1920 two painters, prob-
ably the greatest religious painters of this century, painted, quite indepen-
dently of each other, two pictures which were symbolic of modern man's
predicament and Christ's involvement in humanity's sufferings. The pic-
tures were 'Le Christ dans la Banlieue', by the Frenchman, Georges Rouault
(1871–1958), and 'Christ Carrying the Cross' by the Englishman, Sir Stanley
Spencer (1891–1959). For both painters the presence of Christ in the modern
world was an important theme to which they often returned in their work.
The Churches, however, have failed to see the significance of their achieve-
ments.

In many of his paintings Rouault was interested in portraying the outcast, of society, pathetic clowns, prostitutes and lonely people in sinister, urban landscapes. Into this situation he painted Christ as a man also rejected and scorned by society. For Rouault, redemption meant nothing unless it was seen in relation to the extremities of sin; 'Le Christ dans la Banlieue' sums up many of his ideas about twentieth century man; three lonely figures are seen on a white road in a poor suburb of a town. The painting breathes an atmosphere of urban poverty and loneliness. One of the figures is Christ; he is, Rouault is saying, wherever we are and whatever our condition.

The paintings of Stanley Spencer are quite different. Although the subject of suffering is not absent from his paintings, it was not his preoccupation. Spencer was interested, perhaps obsessed would be a better word, with depicting God in very ordinary situations and with ordinary people. His usual background was his own village of Cookham on the river Thames and, in his imagination, the events of the gospels happen in this village alongside the ordinary village life amidst the people he knew. The effect is at once ordinary and extraordinary. God the Father and Christ become alive as people we might know, and the village and its life is lifted up into a cosmic significance. Holiness breaks through into the ordinary world. In his painting, 'Christ Carrying the Cross', Jesus is led down Cookham High Street. Spencer wrote in a letter to his agent, 'I particularly wished to convey the relationship between the carpenters behind him carrying the ladders and Christ in front carrying the cross, each doing their job of work and doing it just like workmen . . . He was not doing *a* job or *his* job, but *the* job . . .'

Neither artist was recognized by the Churches at the time. Although both were contributing, in very interesting and important ways, to ideas about the incarnation of Christ — and were exhibiting their work — neither of them received a commission from a church. Spencer never painted any work for the Church of England, and it was not until a French writer, Waldemar George, accused the French Church authorities of deliberately ignoring Rouault that he was given a commission to design some windows for a church at Assy in 1945.

This illustrates how, in the twentieth century, there have arisen different worlds in which people, busily concerned with their own affairs, may have virtually no contact with people engaged in another world, even though they may be interested in the same ideas and the same beliefs. Just as there is an art world, so the Christian Churches have become a world of their own: each is poorer for its lack of contact with life beyond its own boundaries.

The Church is poorer because it loses the prophetic role of the artist, the man or woman who can reveal profound truths and form and transmute the symbols of society. The Church has complained that the old, common symbols have lost their power in the secular age of modern times, but the truth is that the Church has lost contact with the people who deal in signs and

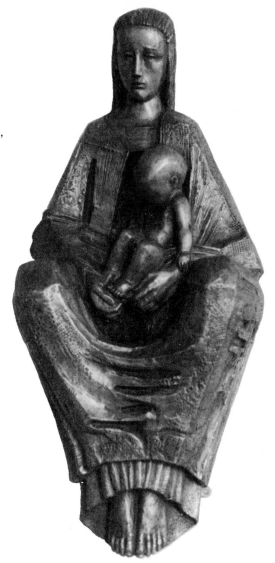

Plate 19
WILLI SOUKUP
Virgin and Child, (c.1960), cast alloy,
the Pilgrim chapel,
St Mary's Abbey, West Malling

symbols, the contemporary artists, and the Church's worship suffers in consequence. Bewildered by a modern art that does not copy nature, the Church has made the mistake of thinking that art today has nothing to say for Christianity.

The Swiss painter, Paul Klee, once said, 'Art does not reproduce the visible, rather it makes visible.' There should be no difficulty for Christians in understanding this statement, because the idea of an image making something visible is deeply embedded in what is believed about Jesus Christ. St Paul calls him, 'the image of the invisible God' in his letter to the Colossians. Christ, in the gospels, makes visible the Father. Men and women cannot see God but it is Christianity's claim that they can know him more completely than in any other way, through the life, the teaching and the ultimate sacrifice of Jesus Christ. He is unique, the firstborn, the image of God the Father, holding all things together.

An artist, trying in his own way, to make things visible, is following the same path as Christ. Whether he knows this or not, and whether he cares or not does not matter; Christ has gone this way before him.

6. The new approaches

The year was 1912. In his Parisian studio, the Spanish painter, Pablo Picasso, began to experiment with collage, a new technique of pasting objects on to paintings. His first attempt was his 'Still Life with Chaircaning' and it offered a new direction to Cubist painting and revolutionized theories of art.

The art critic, Roger Fry held his second 'Post-Impressionist' exhibition at the Grafton Galleries in London. The British art-going public, still convinced that the aim of painting was the descriptive imitation of natural forms, regarded the works as extravagant and eccentric.

'*Foundations*', a collection of theological essays by some leading British scholars, was published as 'a statement of Christian belief in terms of modern thought'. It was a milestone in the development of modern liberal theology.

Percy Dearmer, in co-operation with Messrs A.R. Mowbray & Company Ltd, founded the Warham Guild, an association of artists and craftsmen dedicated to making church furnishings and vestments according to the principles of the pseudo-medieval 'English Usage' for the Church of England.

By placing these quite unrelated events together, unrelated that is except for the matter of time, it is possible to get some idea of the position church art in England held during the first decades of the twentieth century. At the turn of the century there was a great deal of questioning about traditional ideas and values. Christianity was not exempt from this and, similarly, many artists were asking questions about the underlying accepted ideas in the visual arts.

In this situation it might be expected that those artists and craftsmen who worked on church commissions, being concerned both with Christian religious beliefs and with the basic ideas in the visual arts, would have been affected by the debates that were growing up around them; but this is not so. English church art carried on exactly as it had done for decades, oblivious to the changing situation.

Biblical criticism, the application of modern literary and historical critical methods to the study of the Bible, had started occupying scholars' attention in the nineteenth century and continued well into the next. One probable effect has been to create a renewal of interest in other areas of church life which have been a mark of twentieth century Christianity: the reform of the liturgy, interchurch relationships, and the study of the social and political implications of the Christian gospel.

Plate 20 CHURCH OF THE ASCENSION, Crownhill, Plymouth
ROBERT POTTER, architect,
GEOFFREY CLARKE, (1958), sculptured lights in the East wall,
CHARLES NORRIS osb, metal cross (1978)

The questioning of fundamental ideas behind the visual arts began roughly about the same time and they also had their effect upon twentieth century art. Analytical philosophy had questioned the conventional ideas about what beauty and art really were. This had a great effect upon artists and writers who were working in Paris around the turn of the century. 'What *is* beauty anyway? 'asked 'Picasso, 'There's no such thing.' 'Nowadays we like ugliness as well as beauty,' wrote Apollinaire, 'This monster beauty is not eternal.' For the artistic circle: around Picasso and Apollinaire beauty was a worn-out concept.

The result of these new ideas was that artists started to see a painting or a sculpture not as a representation of something else but as a thing in itself, with its own stardards, autonomous, dependent upon nothing but itself and needing no other function. The Impressionists and their heirs were more interested in making a picture than in representing some aspect of reality outside the picture. They were interested in the paint, the surface, in the colour, even in the frame for its own sake. 'Instead of trying to reproduce exactly what I have before my eyes,' wrote Vincent van Gogh in 1889, 'I use colour more arbitrarily so as to express myself forcibly.'

36

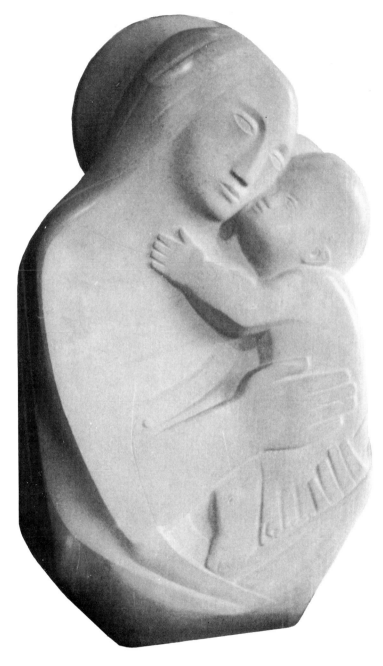

Plate 21 Dame BARBARA HEPWORTH *Virgin and Child* (c.1970), stone,
St Ia of Porthia, St Ives, Cornwall
A parishioner's contribution to her parish church.

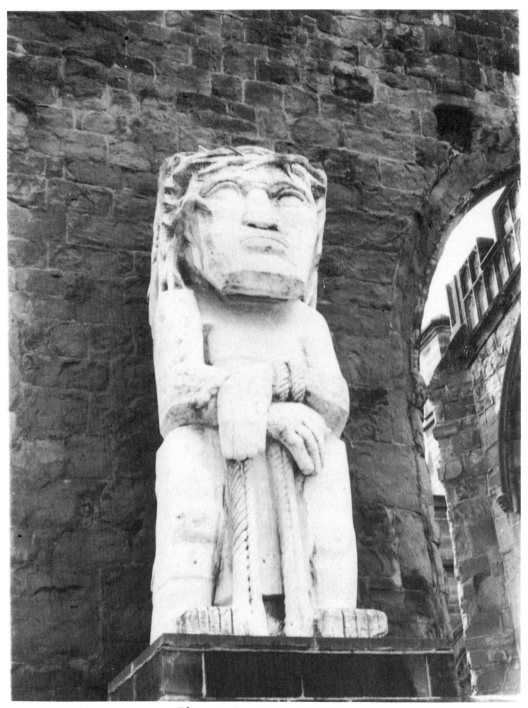

Plate 22 Sir JACOB EPSTEIN
Ecce Homo (1935), Subiaco stone, The statue created great controversy when it was first exhibited. After several Anglican priests had tried, unsuccessfully, to offer it a home it has come to rest in the remains of the old cathedral at Coventry.

Inevitably new ideas about a work of art meant that there must be a new way of looking at it. It was considered desirable to maintain a certain distance from a work; a savouring of, rather than an involvement in, the beliefs that surround a subject was important in order to appreciate a modern work of art.

These new ways of looking at art were a long way from the idea of seeing a work of art as a symbol of the reality of God, and when English churchmen were confronted with examples of modern works it appeared that very few of them understood anything at all about the fundamental new ideas. Not only did it seem to them that modern art could never be a channel for seeing the glory of God, but it often appeared that the modern artist was glorying in distortion and obscurities for their own sake and even wallowing in the obscene. Bishop George Bell considered Picasso the 'devil incarnate'. Could new works of art be used in church ever again? If they were now as autonomous as artists claimed they were, had they any place in a church?

Artists who have accepted church commissions during this century have found themselves in something of a dilemma. Do they dare to leap the divide between the modern and the traditional and invent a contemporary stylistic formula for traditional Christian subjects, or do they reconcile their own vision with the traditional formulas in the hope of being able to achieve up-to-date compromise? For years many artists have avoided the issue, ignored modern art theory and reverted to traditional 'church' styles.

English churches, however, are eternally in the debt of several major artists and, in particular, Henry Moore, Sir Jacob Epstein and Dame Barbara Hepworth who have refused to compromise their ideas. Despite many criticisms aimed at them and even the withdrawal of commissions, they have created works of art in which they have believed. They maintain that their work has continuity with the past and also that a modern work of art can properly find its place within a Christian church.

AUTONOMY AND SYMBOLISM

It has been claimed that modern art should be judged by its own standards and be dependent upon nothing other than itself with no other function than to be itself. Autonomy means that a work of art may stand beside nature on equal terms, that it is no longer dependent upon nature as the source of its inspiration. Natural beauty need no longer be a condition of a work of art and it need have nothing to do with the aesthetics of natural beauty. Is this possible for a religious work of art, a work that is not just about a religious subject but one which speaks of the realities of God? Does not the very nature of autonomy prohibit this? The answer depends upon what is meant by a symbol.

Works of art are often described, rather loosely in many cases, as being symbolic. This means that they are more than just a sign, which points

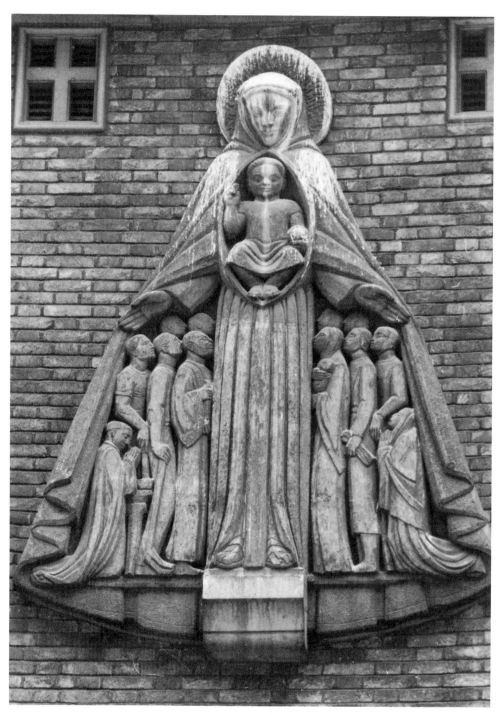

Plate 23 GEORGES SAUPIQUE *La Vierge de Miséricorde* (1953),
stone relief, on the facade of Notre Dame de France, Leicester Place, London

40

towards something, but in some interior way are participating in that to which they refer. A symbolic image is one with associations, bringing out a superior reality; a sign but far more than a sign. In fact a work of art that is symbolic is one that can stand by itself and also participate in something beyond itself. A holy icon is not just a kind of telescope giving a glimpse of something divine, but an object worth considering in its own right, which is why St Basil the Great could claim that the honour given to the images passes over to the prototype. The icon is a work of art with its own integrity which participates in something greater than itself.

The trouble with poor and mediocre works of art is that they do not have this integrity; they are unable to stand on their own. Their existence is justified only by the associations which they wish to convey. Inevitably they trivialize their message. A great work of art, however, has its own autonomy, because it is symbolic. Barbara Hepworth wrote that, 'All true works of art are an act of praise. Out of inert substance a new inevitable idea is born which is of itself an apprehension of the force, of life. It is an acknowledgement of the external power which enables man to create in an infinitude of ways visions which all share. A perception of the holiness of life and the universe.'

SEARCH FOR QUALITY AND RENEWAL

It is not too optimistic to claim that, with the building of Coventry and the other two new cathedrals, with the example of some leading British sculptors and painters and the influence of a few enlightened churchmen, a revival of church art has appeared in this country since the 1960s. There are signs that the search for quality rather than caution has become an ingredient in commissioning new works, and also that, despite economic difficulties, new works of art are still being placed in churches all over the country.

However, many of these new works can only be described as merely decorative to the exclusion of the other uses to which art has been used in church in the past. Too few modern works actually aim at teaching something to the viewer, very few appear to aim at inspiring the worshipper and extending his imagination. Decoration — that echo of the Arts and Crafts Movement — still appears to be the main concern of many artists and their ecclesiastical patrons.

A church, particularly a cathedral, is a public place often visited by hundreds — if not thousands — of people every year. An artist who has some work inside a cathedral has the advantage of a greater number of people seeing it than would be the case if the work were in an art gallery. But the benefits are not only on his side. The Church benefits from modern works of art because, by encouraging the artist, it has welcomed new insights into, and new experiences of, the Christian faith. Examples of this may be seen in the Stations of the Cross, those pious, dull copies of catholic devotion on the walls of many English churches, which achieve a new, disturbing but

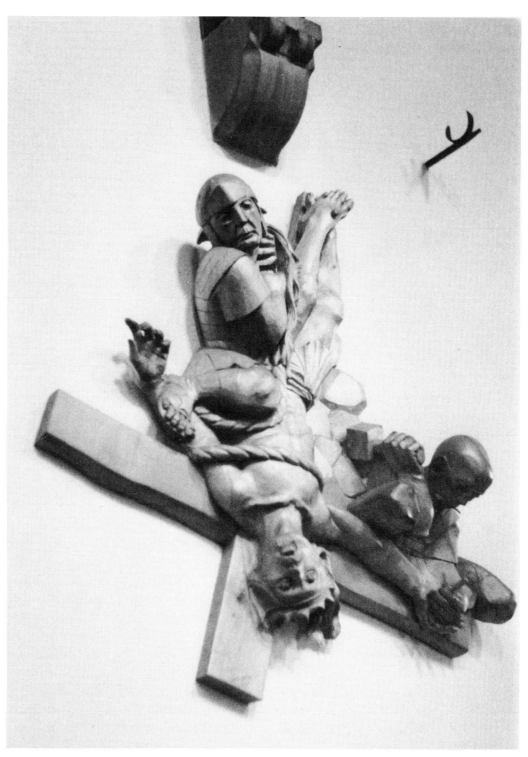

Plate 24 TOM PREATOR Station: *Christ is nailed to the Cross* (1979), elmwood, St George, Taunton
*The forshortened perspective and upside-down effect emphasises the agony of Jesus and
the theme of binding and loosing, symbolized by the rope, runs right through these Stations.*

compelling, lease of life when they are designed by Arthur Dooley for St Mary's, Leyland, or by Tom Preator for St George's, Taunton, or Tom Hill for Christ the King, Langney. The families that picnic on the grass outside Salisbury cathedral have a new experience of Mary, the Mother of God. Elizabeth Frink's 'Walking Madonna' is not a pretty conventional girl but a middle-aged mother, gaunt and purposeful, striding from the quiet of the cathedral to the noise and bustle of the city. It is an image of hope for modern Mother Church herself, coming out into the world with a double purpose, to offer to mankind the vision of God and to call it to the pursuit of that vision.

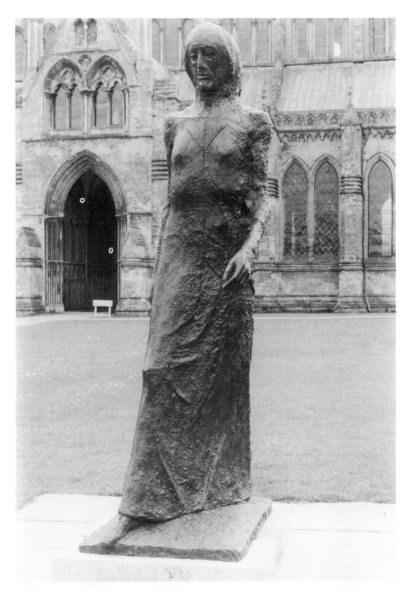

Plate 25
ELIZABETH FRINK
Walking Madonna
(1981), metal,
in the grounds of
Salisbury Cathedral

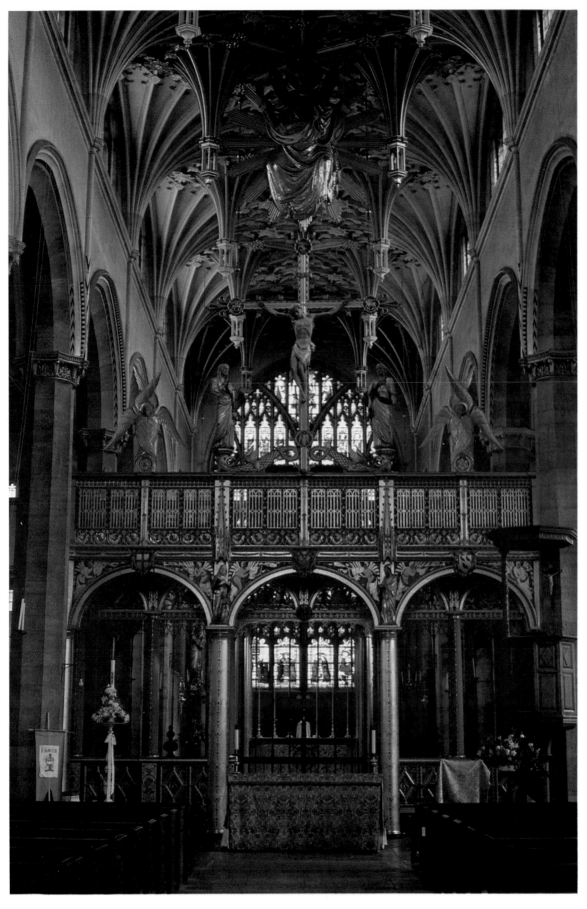

Plate 1
SIR NINIAN COMPER
rood (1908–31),
Church of St Mary,
Wellingborough

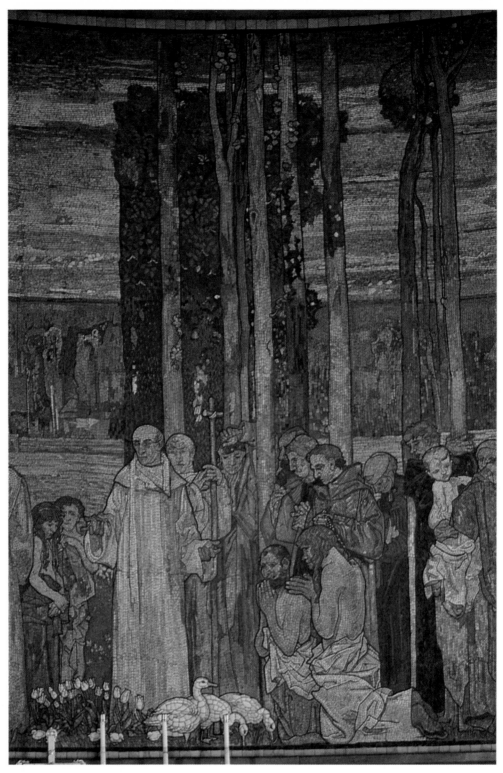

Plate 2 SIR FRANK BRANGWYN *Life of St Aidan* (detail) (1916), mosaic.
Church of St Aidan, Leeds

Plate 3 (opposite, above) JOHN LAWSON panel (1982), glass (c. 30 x 24 inches)
Chapel, Deaconess Community of St Andrew, Notting Hill, London

Plate 4 (opposite, below) HENRY WILSON altar rail (detail) (1905), metal.
Church of St Bartholomew, Brighton

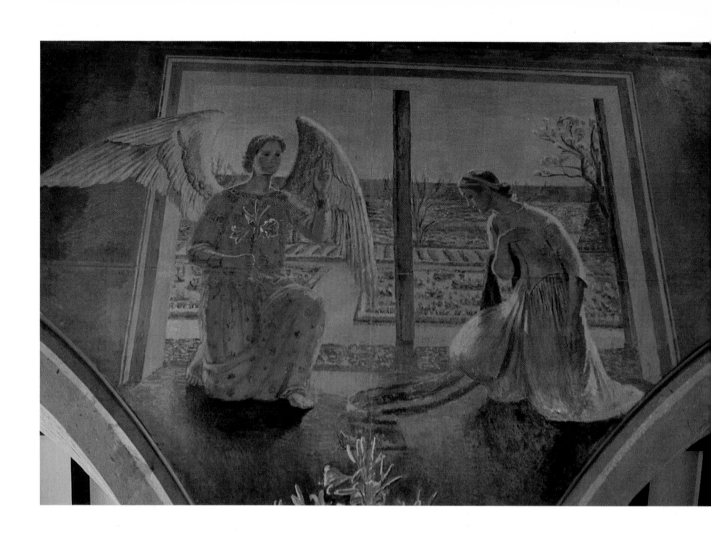

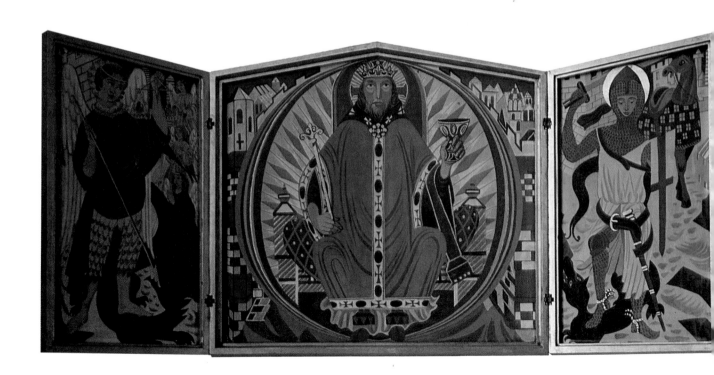

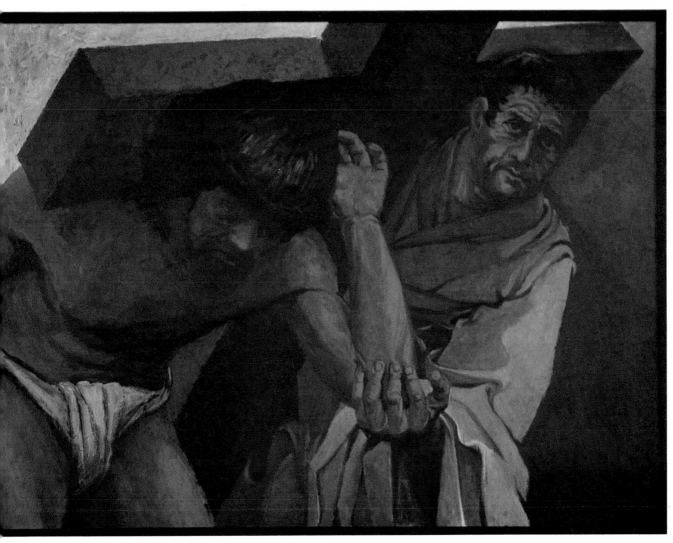

Plate 7 TOM HILL Station of the Cross (1968) painting,
Church of Christ the King, Langney, Eastbourne

ate 5 (opposite, above) VANESSA BELL *Annunciation* (1941), mural.
nurch of St Michael and All Angels, Berwick, Sussex

ate 6 (opposite, below) MARY ADSHEAD *Christ in Glory* (1956),
ptych, painting on wood. Church of St Mary, Plymstock

Plate 8 HANS FEIBUSCH *Pilgrim's Progress* (c. 1940), mural.
Crypt, Church of St Elizabeth, Eastbourne

Plate 9 (above, opposite) STEPHEN WILLIAMS processional cross (1982), met
Church of St Mary de Castro, Leicester

Plate 10 (opposite, below) GEOFFREY CLARKE high altar cross (c. 1960), meta
Cathedral of St Michael, Coventry

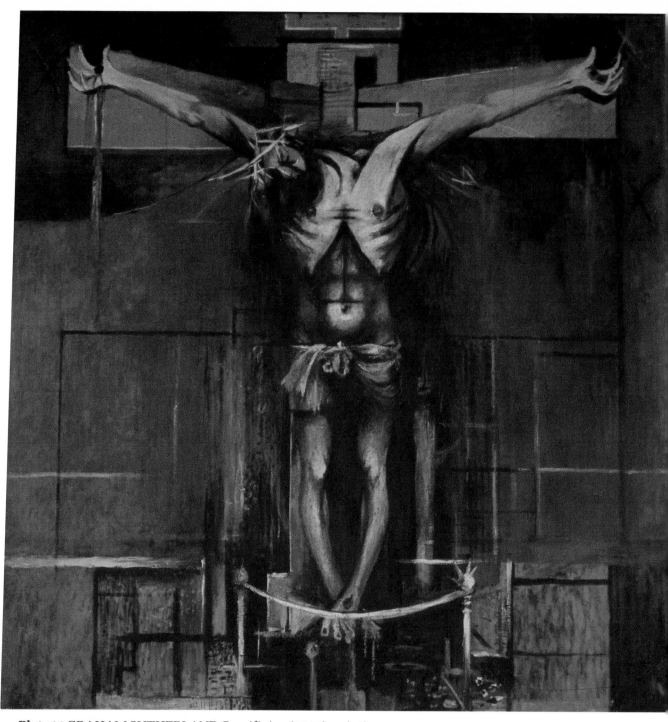

Plate 11 GRAHAM SUTHERLAND *Crucifixion* (1946), painting.
Church of St Matthew, Northampton

Plate 12 (opposite) LEROY DE MAISTRE *Crucifixion* (1962), paintin
Church of the Immaculate Heart of Mary, Hayes

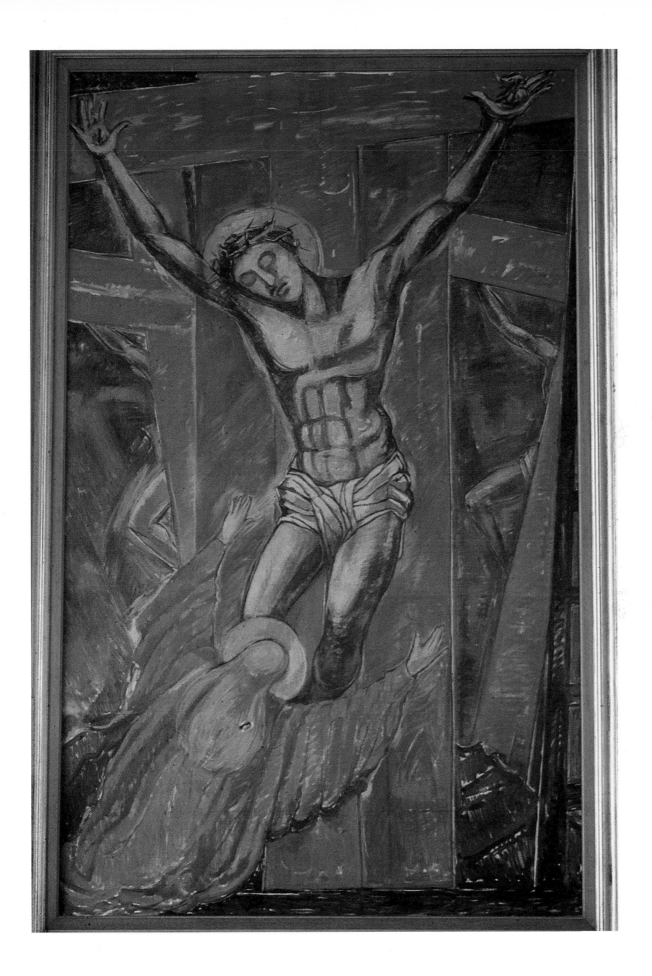

Plate 14 (above) JOHN PIPER Lady chapel window (1969), Church of All Hallows, Wellingborough

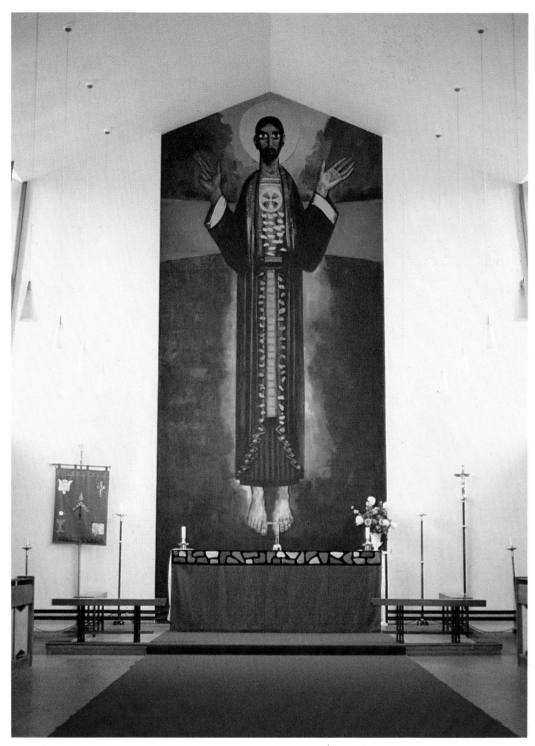

Plate 15 MARTYN WRIGHT *St Thomas the Apostle* (1961), mural.
Church of St Thomas, Birmingham

Plate 16 (opposite) ROBERT BRUMBY *Madonna and Child* (c. 1960), cerami‹
Metropolitan Cathedral of Christ the King, Liverpool

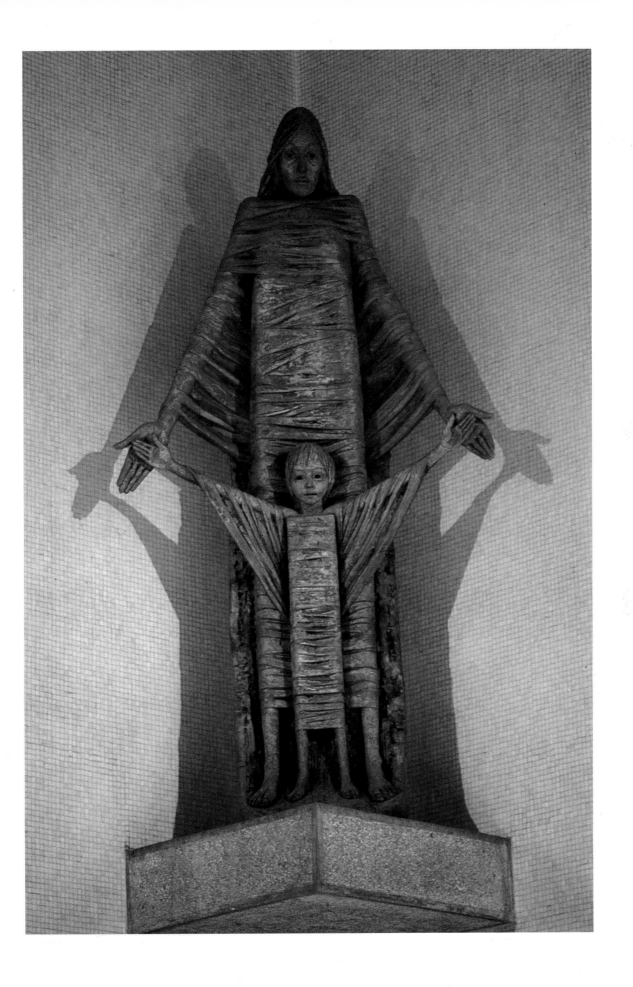

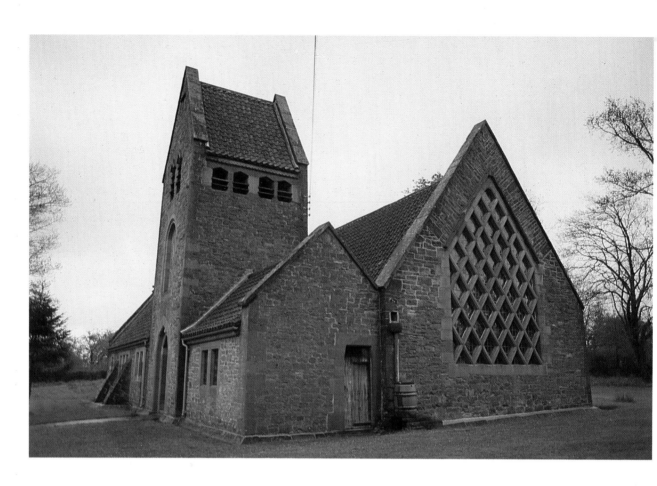

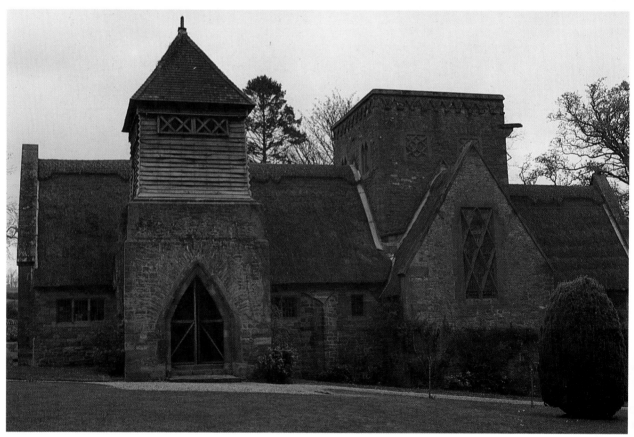

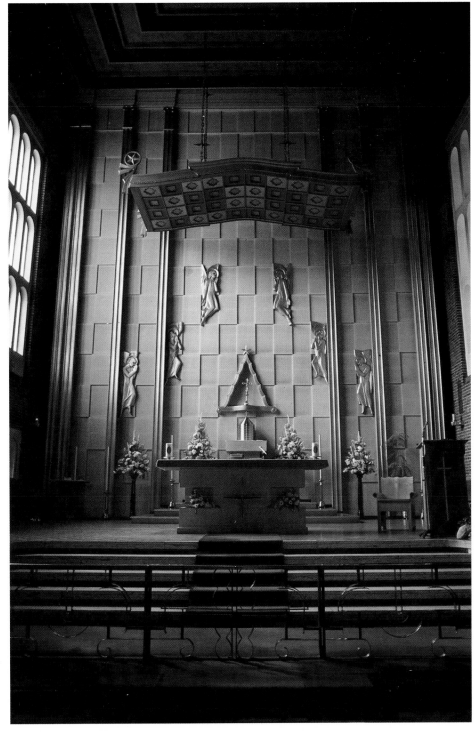

Plate 19 FRANCIS VELARDE architect, reredos and sanctuary (1936 but rearranged since), Church of St Monica, Bootle. A rare example of Art Deco church architecture

ate 17 (opposite, above) RANDALL WELLS architect (1904),
urch of St Edward the Confessor, Kempley

ate 18 (opposite, below) WILLIAM LETHABY architect (1901–02),
urch of All Saints, Brockhampton-by-Ross

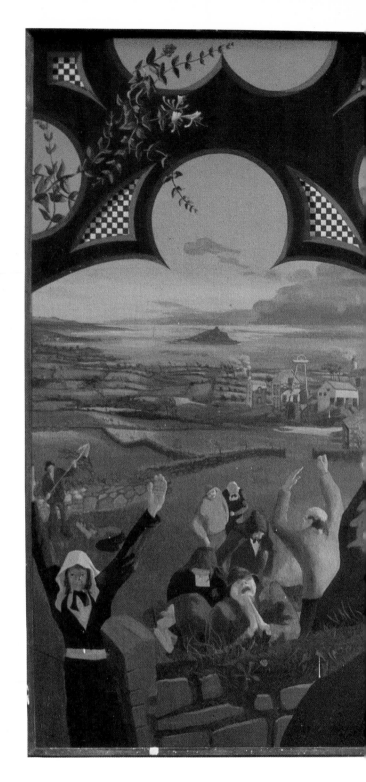

Plate 20 RONALD COPAS
Robert Aitken preaching at Pendeen (c. 1972),
(c. 36 x 60 inches) triptych, painting on wood,
Church of St Andrew, Pencoy

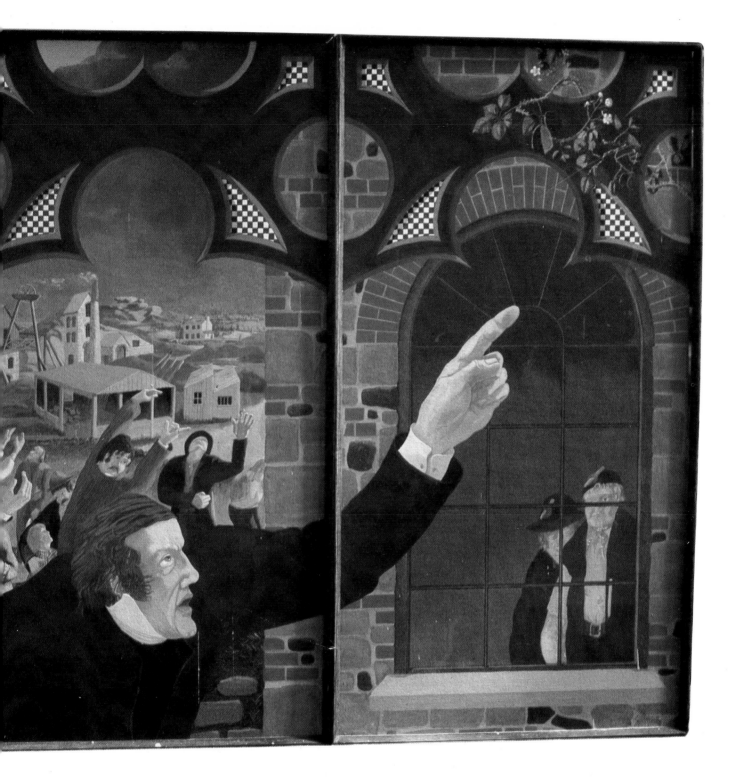

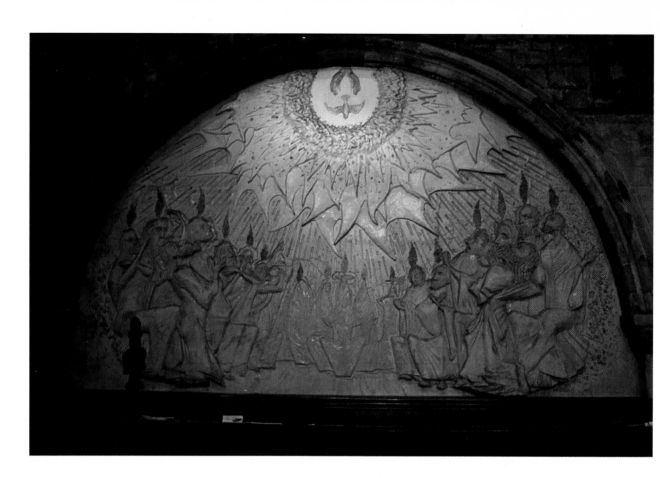

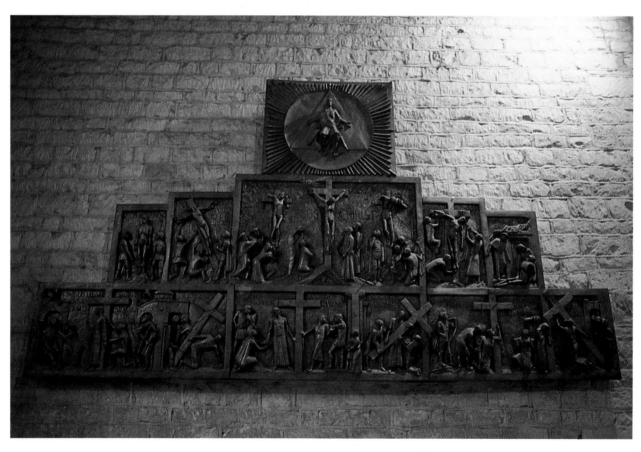

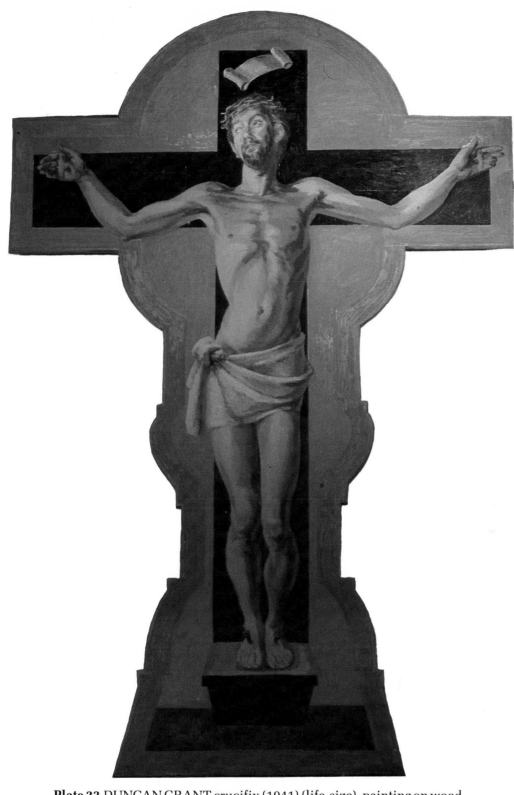

Plate 23 DUNCAN GRANT crucifix (1941) (life-size), painting on wood.
Church of St Michael and All Angels, Berwick, Sussex

ate 21 (opposite, above) NOEL BLACK *St Mary at Pentecost* (1967), fibre glass
ief. Church of St Mary de Castro, Leicester

ate 22 (opposite, below) ULRICA LLOYD *The Way of the Cross*, metal and fibre glass.
urch of All Saints, Woolstone

63

Plate 24 (above)
SISTER MARY SIMON OSB
Sleeping Warrior,(1982),
painting (c. 17 x 28 inches),
Abbey of St Mary, West Malling

Plate 25 (right)
RICHARD GREENING
tabernacle door (1980),
fired metal,
Nashdom Abbey, Burnham

Plate 26 (opposite)
SIR NINIAN COMPER
rood panel (1908–31),
painting on wood,
Church of St Mary, Wellingborough

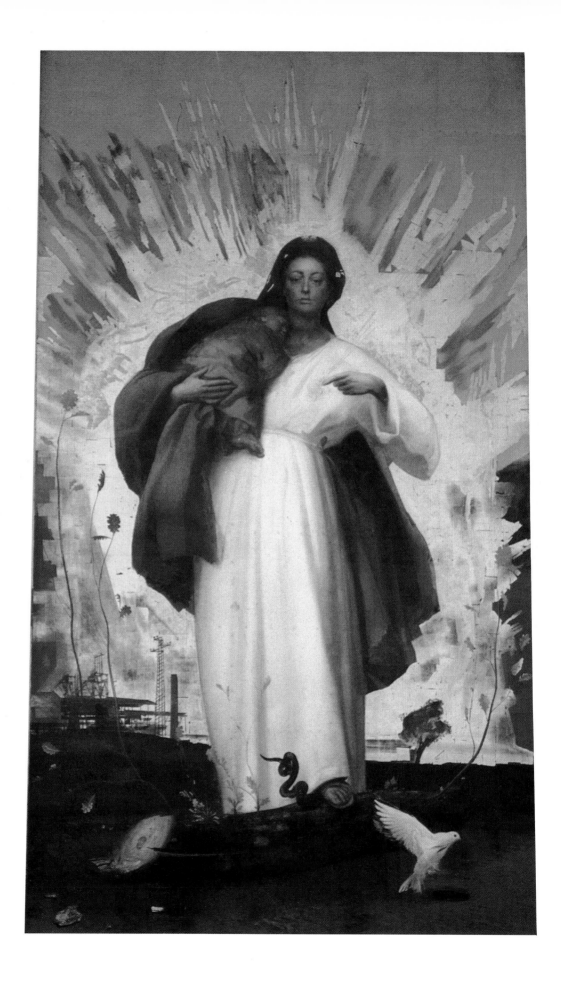

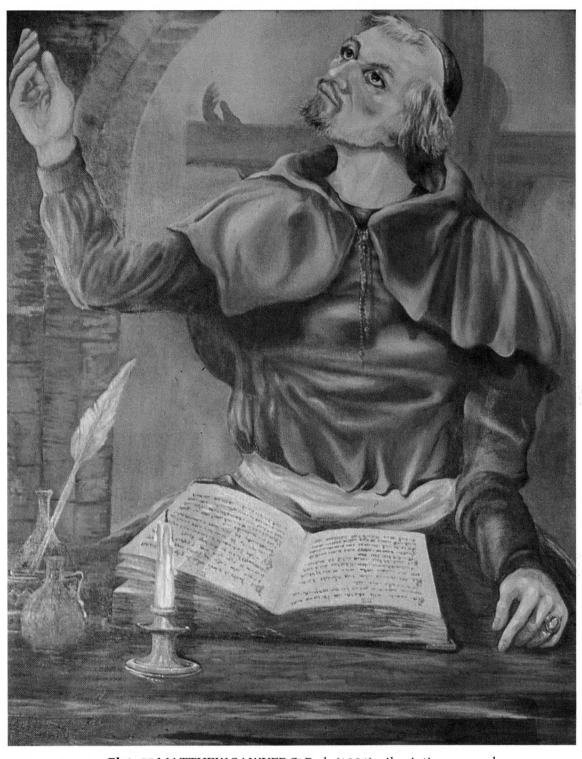

Plate 28 MATTHEW SAWYER *St Bede* (1964), oil painting on wood.
(c. 30 x 36 inches) Church of St Bede, Newsham

ate 27 (opposite) PIETRO ANNIGONI *The Immaculate Heart of Mary* (1962),
inting (almost life-size). Church of the Immaculate Heart of Mary, Hayes

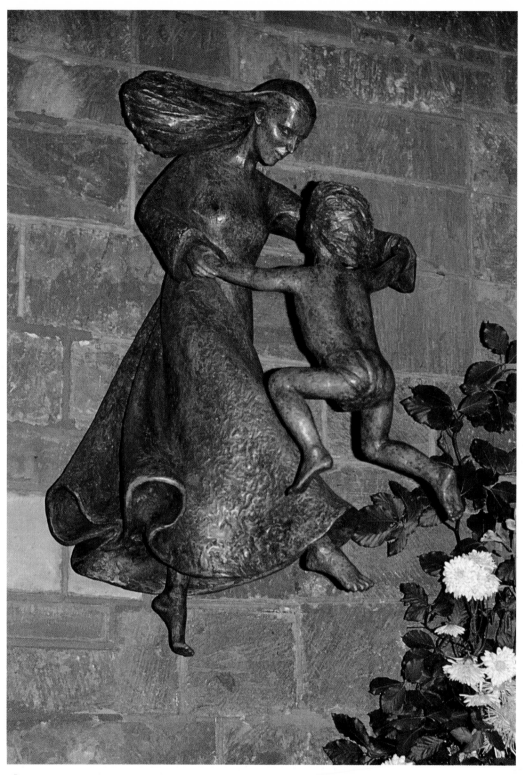

Plate 29 MAUREEN COLPMAN *Madonna and Child*, bronze.
Church of St Luke, Duston

Plate 30 (opposite) HALIMA NALECZ *The World of Creation* (1968), paintin
Church of St John the Evangelist, Paddington, London

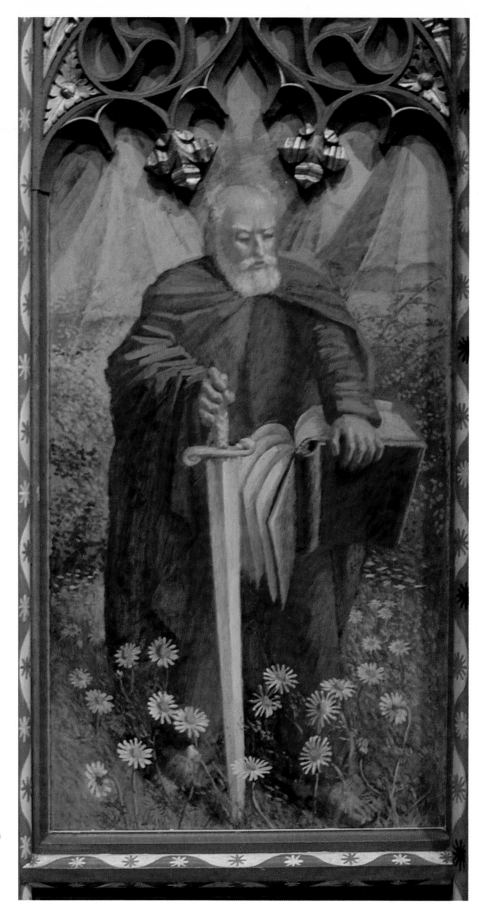

Plate 31 HENRY BIRD
English Saint
painting, rood panel,
Church of All Saints,
Earls Barton

Plate 32 THETIS BLACKER *The Holy City*, batik.
Deaconess Community of St Andrew, Notting Hill, London

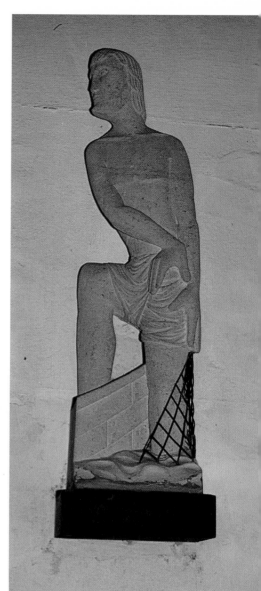

Plate 34 JOHN SKELTON
St Andrew (c. 1960), relief.
Church of St Andrew, Stapleford

Plate 33 (left) GIACOMO MANZU
St Teresa of Lisieux, bronze relief.
Metropolitan Cathedral of the Most Preciou[s]
Blood, Westminster

IV. JESUS MEETS HIS MOTHER

BENEDICTA TU IN MULIERIBUS

Plate 35 ERIC GILL Station of the Cross (1913–18), stone. Metropolitan Cathedral of the Most Precious Blood, Westminster. Considered to be one of the finest religious works of art found in a church in England.

Plate 36 EVIE HONE window (1955), Church of All Hallows, Wellingborough

Plate 37 (opposite, above) HAROLD HARVEY *St Fingar* (1924), stall panel painting. Church of St Hilary of Poitiers, St Hilary

Plate 38 GLADYS HYNES (opposite below) *St Morwena* (c.1920), stall panel painting, Church of St Hilary of Poitiers, St Hilary

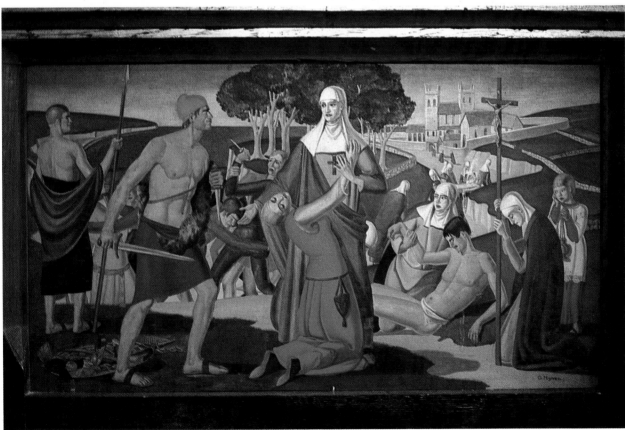

Plate 39 NUNS OF VITA ET PAX COMMUNITY
Station of the Cross, card.
Crypt, Metropolitan Cathedral of Christ the King, Liverpool

Appendices

APPENDIX 1

USEFUL ADDRESSES

The Council for the Care of Churches
Offices and library: 83, London Wall,
London EC2M 5NA
(01–638–0971)

The Department of Art and Architecture of the Liturgical Commission
The Chairman: The Revd K. Nugent SJ, 114, Mount Street,
London W1Y 6AH
(01–493–7811)

The Society of Catholic Artists
The Honorary Secretary: Patrick Pike Esq., 60, Burrard Road,
London NW6 1DD
(01–435–2939)

Societe Internationale des Artistes Chretiens
English Speaking Region: The Secretary, 29, Trott Street,
London SW11 3DS
(01–228–1675)

APPENDIX 2

A SELECTION OF CHURCHES WHERE MODERN WORKS OF ART CAN BE FOUND

A more comprehensive list will be found in *Modern Art in Church, a Gazetteer*
which can be obtained from:
 The Publications Officer, Royal College of Art,
 Kensington Gore, London SW7 2EU (price £3)

ALDEBURGH Suffolk
St Peter and St Paul John Piper window (1980)

 A memorial to the composer, Benjamin Britten

ALNMOUTH Northumberland
The Friary Br James Anthony SSF icon
 A sister CSCI sculpture (1974)
 The Risen Christ

AYLESBURY Buckinghamshire
United Reformed church Jane McDonald windows (1982)

AYLESFORD Kent
The Priory Philip L. Clark sculpture (1949)
 The Scapular Vision

	Michael Clark	sculpture (1960) *The Assumption*
	Moira Forsyth	window (1957)
	Adam Kossowski	ceramics (1950–66)
	Dom Charles Norris OSB	windows
	Br Michael O Carm	stoop

BARNHAM Suffolk

St Mary the Virgin	Henry Moore	sculpture (1945) *Virgin and Child*

BATH Avon

St Bartholomew	Mark Angus	window (1981/82)
St Stephen	Mark Angus	window (1982)

BERWICK East Sussex

St Michael	Vanessa and Quentin Bell	murals
	Duncan Grant	murals (1941–43)

BIRMINGHAM West Midlands

St Agatha, Sparkbrook	L.C.Evetts	window (1961)
	Margaret Greatorex	tapestry (1979) *Christ the King*
	Omar Ramsden	silver plate
	Wood, Kendrick and Williams	altar (1964)
St Aidan, Small Heath	F.Bligh Bond	reredos and altar (1910)
	Arthur Gaskin	morse (1902) and plate
	John Hardman	window (1930)

BLACKBURN Lancashire

St Gabriel	Francis X.Velarde	architecture and furnishings (1932)
Cathedral	John Hayward	window and font cover sculpture (1965) *Christ the Worker*
	A. Hunston	rood figures
	Turangeau le Pape	sculpture *St Martin of Tours*
	Omar Ramsden	cross and candlesticks (1926)
	Francis Stephens	tympanum and doors
	Josephina de Vasconcelles	sculpture (1973) *Mother and Child*

BLACKHEATH Surrey

St Martin	Harrison Townsend	architecture
	L. Merritt	murals

Built in an Art Nouveau style

BLETCHINGLEY Surrey

Southwark Ordination Conference Centre	John Hayward	painting (1965) *Christ the Worker*

BOOTLE Merseyside

St Michael	Henry Holiday	window (1899)

BOTHENHAMPTON Dorset

Holy Trinity	William Lethaby	altar frontal (gesso) (1880)
	Edward Prior	architecture (1887–89)
	Christopher Whall	window (1895)

An Arts and Crafts style church

BRADFORD West Yorkshire

| Church of the First Martyrs | Eric Gill | sculpture (1935) |
| | | *St Anthony of Padua* |

Built in the round with a central altar, an interesting church for its date

BRIGHTON East Sussex

| St Bartholomew | Hamilton Jackson | mosaics (1911) |
| | Henry Wilson | high altar, Lady altar and chalice (1908) |

BRISTOL Avon

Cathedral	Naomi Blake	sculpture (1980)
		Victims of Persecution
	Ernst Blensdoft	sculpture (1951)
		Abraham's sacrifice
	Keith New	window
	Louis Ward	painting
	Malcolm Woodward	crucifix
		Jesus in Gethsemane

BROCKHAMPTON-BY-ROSS Herefordshire

All Saints	Edward Burne-Jones	tapestry
	William Lethaby	architecture (1901–1902)
	Christopher Whall	windows (1916 and 1918)

An Arts and Crafts church with a thatched roof

BROXTED Essex

| St Mary | Francis Stephens | altar, reredos, windows and Stations (1967) |

BUCKINGHAM Buckinghamshire

St Bernadine of Siena	Angela Godfrey	doors
	Martin Hughes	murals (1974)
	Dom Charles Norris OSB	window

BURGESS HILL West Sussex

| St Wilfred | Frank Brangwyn | Stations |

CANTLEY South Yorkshire

| St Wilfred | Ninian Comper | furnishings (1893) |

CHICHESTER West Sussex

Cathedral	Marc Chagall	window (1978)
	Geoffrey Clarke	candlesticks, altar rails and pulpit
	Cecil Collins	painting (1973)
		Icon of Divine Light
	Hans Feibusch	painting (1951)
		Baptism of Christ

	John Piper	high altar hangings (1966)
	John Skelton	font
	Graham Sutherland	painting (1961) *Noli Me Tangere*

CLIFTON Avon

All Saints
Cathedral

	Randall Blacking	baldacchino (1952)
	Henry Haig	baptistry windows (1970)
	Terry Jones	sculpture *Our Lady*
	William Mitchell	Stations (1970)
	John Piper	windows (1966) *River and Tree of Life*
	John Skelton	Engraving on piscina (1966)
	Christopher Webb	window (1967) *Christ in Glory*

COALVILLE Leicestershire

Mount St Bernard Abbey

	Eric Gill	choir stalls (1939)
	Vincent Eley	calvary
	Francis O'Malley	cross (1939)

COMPTON BEAUCHAMP Oxfordshire

St Swithin

	Ulrica Lloyd	sculpture
	Martin Travers	altar, reredos and furnishings (1927)

COOKHAM Berkshire

Holy Trinity

	Stanley Spencer	painting (1920) *The Last Supper*

COVENTRY West Midlands

Cathedral

	Ralph Beyer	lettering (1960) *Tablets of Word*
	Geoffrey Clarke	high altar cross, steeple cross and windows (1960)
	Hans Coper	ceramic candlesticks (1960)
	Leslie Durbin	silver plate (1960)
	Jacob Epstein	sculpture (1960) *St Michael and the Devil*
	Clark Fitz-Gerald	sculpture (1971) *The Plumbline and the City*
	Einar Forseth	floor mosaic (1960)
	Elizabeth Frink	lectern eagle (1960)
	John Hutton	engraved glass (1960)
	Helen Jennings	sculpture *Christ Crucified*
	Lawrence Lee	windows (1960)
	John Piper	windows (1960)
	Jindrich Severa	crucifix
	Stephen Sykes	sculptured relief (1960)
	Ivan Theimer	sculpture *Head of Persecuted Christ*
	Margaret Traherne	window (1960)

Christ Church, Childsmoor	Erwin Bossanyi	windows (1956)
	Pierre Fourmaintraux	window
	John Skelton	sculptured figures (1958)

CRAWLEY West Sussex

Worth Abbey	Nuns of Vita et Pax	chasubles
	Arthur Pollen	sculpture *Our Lady*

DENTON Northamptonshire

St Margaret	Henry Bird	murals

DOWNSIDE Somerset

Abbey	Ninian Comper	altar, reredos and window sculpture *Our Lady & St Benedict*
	Adam Kossowski	ceramic relief
	Peter Watts	sculptures
	Geoffrey Webb	window
	Dom Hubert van Zeller OSB	sculpture *St Joseph* crucifix and relief

DURHAM Durham

Cathedral	Ninian Comper	St Cuthbert's shrine
	Hugh Easton	windows (1934/40)
	Henry Holiday	windows
	George Pace	three copes (1957) cross (1966)

DUSTON Northamptonshire

St Luke	Maureen Colpman	sculpture *Madonna and Child*
St Crispin's Hospital chapel	Henry Bird	murals

EARLS BARTON Northamptonshire

All Saints	Henry Bird	paintings on the rood
	Christopher Fiddes	painting *Crucifixion with Graffiti*

EASTBOURNE East Sussex

St Elizabeth	Hans Feibusch	murals *Pilgrim's Progress*
	E.W. Tristram	murals (1938)
Christ the King, Langney	Tom Hill	Stations (1968)

ELVEDEN Suffolk

St Andrew and St Patrick	Frank Brangwyn	window (1938)
	Hugh Easton	window (1947)
	Lawrence Lee	window (1971)

ETON Berkshire

College chapel	Evie Hone	window
	John Piper	windows

ETTINGTON Warwickshire

Holy Trinity	Evie Hone	windows (1948–49)

FARNBOROUGH Hampshire

Abbey	Frank Brangwyn	Stations
	Nuns of Stanbrook	crucifix

GORLESTON-ON-SEA Norfolk

| St Peter | Eric Gill | designed the building (1939) |
| | Denis Tegetmeier | sculpture (1962) |

GREAT WARLEY Essex

| St Mary the Virgin | William Reynolds-Stephens | screen (1904) |
| | Harrison Townsend | architecture and furnishings (1904) |

A rare Art Nouveau-style church

GUILDFORD Surrey

Cathedral	Brenda Bridge	painted cross
	John Cobbett	sculpture *Madonna and Child*
	Alan Collins	sculpture
	Moira Forsyth	windows
	Eric Gill	sculpture *St John the Baptist*
	Vernon Hill	bronze doors
	Denis Huntley	sculptures
	John Hutton	glass doors
	John Skeaping	sculpture *Angels*
	Douglas Stephen	sculpture *Madonna*

HASLEMERE Surrey

St Christopher	Romney Green	altar (1902)
	Luther Hooper	tapestry & altar hangings
	Morris and Co.	wall hangings
	Charles Spooner and Mrs Spooner	architecture, reredos & decoration

HAYES Greater London

Immaculate Heart of Mary	Pietro Annigoni	painting (1962) *Mary*
	Roy de Maistre	painting (1961) *Our Lady of the Wayside*
	David O'Connell	painting (1962) *St Jude the Apostle*
	William Redgrave	windows (1962)

HILFIELD Dorset

Friary	A sister CSCI	sculpture *St Francis* and churchyard cross
	Enzo Plazzotta	sculpture (1979) *Crucifixion and Figures*
	Josephina de Vasconcelles	sculpture *St Francis*
	Members of a Tanzanian tribe	sculpture *St Francis*

JARROW Tyne & Wear

| St Paul | Fenwick Lawson | rood *Christ Ascending* (c1972) *St Bede* elmwood (c1972) *St Michael and the Devil* (c1960) East window (1950) |

JERSEY Channel Islands
St Matthew, Millbrook René Lalique glass font and screens

LEEDS West Yorkshire
St Aidan, Chapeltown Frank Brangwyn mosaic (1916)
 St Aidan

LEEK Staffordshire
All Saints G. Horsley panelling and painting
 Annunciation
 Hamilton Jackson reredos painting
 Leek School of Needlework embroidery
 William Lethaby reredos

LEICESTER Leicestershire
St Mary de Castro Noel Black relief
 Mary at Pentecost (1967)
 Stephen Leonard-Williams processional cross (1982)

LEYLAND Lancashire
St Mary Arthur Dooley Stations (1962)
 J.K. Faczynski painting (1964)
 St Benedict
 Patrick Reyntiens windows (1954)

LIVERPOOL Merseyside
Anglican Cathedral George Bodley Lady chapel reredos
 E.Carter-Preston sculpture *Pieta*
 Carl Edwards windows *Creation*
 Walter Gilbert reredos panels
 Morris and Co. windows
 Josephina de Vasconcelles sculpture
 The Holy Family
Metropolitan Cathedral David Atkins floor design and baptistry
 gates (1960)
 Ernst Blensdorf sculptures (1960)
 Angels and *Prophet*
 Robert Brumby ceramic sculpture
 Madonna and Child
 Virginio Ciminaghi stoop and bronze figures
 Arthur Dooley sculpture (1980)
 Resurrection Figure
 sculpture (1983)
 Crucifixion
 Howard Faulkner Stations (1950)
 Elizabeth Frink crucifix (1967)
 Robert Gooden cross and candlesticks
 B. McDermott tapestry
 William Mitchell main doors (1960) and
 carving
 John Piper and Patrick lantern windows (1960)
 Reyntiens
 Ceri Richards painting
 Margaret Traherne windows (1960)
 Nuns of Vita et Pax tapestry

LONDON

Belgravia, London SW1

Holy Trinity, Sloane Street	Omar Ramsden	candlesticks
	John Tweedsmuir	reredos (1912)
	Christopher Whall	windows (1904–23)
	Henry Wilson	decorations (1890)

City London EC2

St Paul's Cathedral	Beryl Dean	cope (1977)
	Jacob Epstein	bust (1953) *Sir Stafford Cripps*
	Moira Forsyth	windows
	Brian Thomas	windows
	Josephina de Vasconcelles	sculpture *Virgin and Child*
	Astrid Zydower	crib figures

Clarence Gate London NW1

| St Cyprian | Ninian Comper | decorations |

Cockfosters London N14

| Priory of Our Lady | Nuns of Vita et Pax | ten wall hangings |
| Christ the King | Nuns of Vita et Pax | four wall hangings |

East Acton London NW10

St Aidan	Arthur Ayres	sculpture *St Gerard*
	Arthur Buss	window
	George Campbell	sculpture *St Joseph*
	Philip L. Clark	sculpture *St Anthony*
	Arthur Fleischmann	engraved perspex
	Pierre Fourmaintraux	windows
	Adam Kossowski	ceramic reliefs
	Roy de Maistre	paintings: two triptychs (1961)
	Kathleen Parbury	sculptures *St Aidan and St Theresa of Lisieux*
	Graham Sutherland	painting *Crucifixion*(1963)
	Carel Weight	painting (1965) *Transfiguration and Epileptic Boy*

Highgate London N6

| St Michael | Evie Hone | window |

Leicester Place London WC2

Notre Dame de France	Boris Anrep	mosaics
	Jean Cocteau	murals (1960)
	Dom Robert OSB	tapestry *Our Lady*

Notting Hill London W11

| Community of St Andrew Tavistock Road | Thetis Blacker | batik paintings on the Book of Revelation |
| | John Lawson | glass panel (1982) |

Paddington London W2

| St John the Evangelist, Hyde Park Crescent | Marian Bohusz | Painting (1967) *St Michael* |

	Michael Caddy	cross and candlesticks (1970)
	Michael Lewis	painting *Christ with Crown of Thorns*
	Halima Nalecz	paintings, *Good Friday (1968)* *The World of Creation (1968)* *Where the Sky is Born (1970)*
	Bronson Shaw	windows (1983) *Annunciation*

Westminster London SW1

Cathedral	Boris Anrep	mosaics (1953–61)
	Philip L. Clarke	sculpture *St George*
	Clayton and Bell	mosaics *St Gregory and St Augustine*
	Eric Gill	Stations (1913–18)
	Ernest Gimson	Choir stalls (1912)
	Stirling Lee	sculpture *St Andrew*
	Roy de Maistre	Stations (1953)
	Giacomo Manżu	bronze relief *St Teresa of Lisieux*
	Arthur Pollen	sculpture *St Patrick* and crucifix
	Gilbert Pownall	mosaic (1931–32)
	Bainbridge Reynolds	screen in metal
	Christian Symonds	mosaics (1911) crucifix
	Justin Vulliamy	mosaic (1964)

MANCHESTER Greater Manchester

Cathedral	Judy Barry	altar frontal and copes
	Barbara Dawson	cope
	Eric Gill	sculpture (1933) *St Mary, St Denys, St George and Christ*
	Anthony Hollaway	window *Saints*
	Theo Moorman	tapestry (1957) *Annunciation and Nativity* altar frontal and dossal curtain
	Beryl Patten	altar frontal and copes
	Carel Weight	painting (1963) *The Teachings of Christ*
	Charles Wheeler	sculpture *St Mary*

MUCH HADHAM Hertfordshire

| St Andrew | Selwyn Image | window (1891) |
| | Henry Moore | two carved heads over doorway (1953) |

NASHDOM Buckinghamshire

| Abbey | Richard Greening | tabernacle door & corona |
| | Martin Travers | altar |

NORTHAMPTON Northamptonshire
St Matthew

| | Henry Moore | sculpture (1943) *Madonna and Child* |
| | Graham Sutherland | painting (1946) *Crucifixion* |

NORWICH Norfolk
Cathedral

	Stephen Dykes-Bower	cross
	Bernard Fielden	wrought iron screen
	Moira Forsyth	window (1968)
	George Fullard	sculpture (1977) *Mother and Child*
	Pat Russell	altar frontal and vestments
	John Skelton	sculpture (1968) *Pieta* sculpture (1980) *Madonna*

OXFORD Oxfordshire
Campion Hall

	Frank Brangwyn	Stations
	Charles Mahoney	murals
	Roy de Maistre	paintings *Resurrection* (1950) *Head of Christ* (1958)

PARKSTONE Dorset
St Osmund

	Eric Gill	inscription
	MacDonald Gill	painting *Annunciation*
	A. Miller	sculptures *Our Lady* (1923) *St Osmund* (1924)
	Bainbridge Reynolds	altar crosses and candlesticks, lectern & tabernacle (1916–26)

PLYMOUTH Devon
Ascension, Crownhill

	Geoffrey Clarke	sculptured glass (1958)
	Robert Medley	painting under baldacchino (1958)
	Dom Charles Norris OSB	cross (1978)
	Pat Russel	vestments
	Francis Stephens engraved glass doors (1968)	

READING Berkshire
Douai Abbey

	Elizabeth Frink	crucifix (1966)
	Jacqueline Herbert	sculpture *Virgin and Child*
	David John	cross and candlesticks (1978-79) window (1979)
	Dame Werburg Welch OSB	sculpture (1956)

ROKER Tyne & Wear
St Andrew

	Edward Burne-Jones	tapestry
	Eric Gill	inscription
	Ernest Gimson	lectern (1907) altar cross and processional cross
	H.A. Payne	window
	Edward Prior	architecture (1906–07)

88

SAINT HILARY Cornwall

St Hilary of Poitiers	Roger Fry	painting *St Francis*
	Dod Proctor	paintings on the choir stalls
	G. Hynes	*Lives of the Cornish saints (1918–24)*
	Harold Harvey	
	N. Garstin	
	A. Garstin	
	H. Knight	
	E. Proctor	Lady chapel altar painting
	A. Walke	crucifix
	P. Yglesias	

SAINT IVES Cornwall

St Ia of Porthia	Barbara Hepworth	sculpture (1970) *Virgin and Child* and candlesticks

SALISBURY Wiltshire

Cathedral	Elizabeth Frink	sculpture (1981) *Walking Madonna*
	Barbara Hepworth	sculpture (1966) *Construction Crucifixion*
	Henry Holiday	windows
	Gabriel Loire	window (1980) *Prisoners of Conscience*

SOUTHWELL Nottinghamshire

Minster	Alan Coleman	sculpture (1952) *Madonna and Child*
	Jenny Craddock	ceramic candlesticks (1978)
	Peter Inchbald	painting (1950) *Adoration of the Magi*
	Walter Knight	cross and candlesticks (1965)
		sanctuary lamp (1960)
	John Piper	altar frontal (1972)
	Sr Verena CHN	altar frontal
	Cecilia Webb	ceramic (1949) *Holy Family*

STIRCHLEY West Midlands

Ascension	Marc Chagall	window

TAUNTON Somerset

St George	Tom Preator	Stations (1979)

TUDELEY Kent

All Saints	Marc Chagall	window (1967)

WALLSEND Tyne & Wear

St Luke	Wilhelmina Geddes	window (1920) *Crucifixion*
	L.C. Evetts	*window*
St John Evangelist	*Charles Sansbury*	*metal crucifix (1980)*

WALSINGHAM, LITTLE	**Norfolk**	
All Souls	John Hayward	sculpture and window
	Siegfried Pietsch	crucifix
Shrine of Our Lady	Anthony Baynes	painting (1936)
	Enid Chadwick	painting (1936)
	Ninian Comper	reredos (1959)
Slipper chapel	Alan Sorrell	painting (1953) *Our Lady of Walsingham and English Saints*
	Geoffrey Webb	window (1953)
WELLINGBOROUGH	**Northamptonshire**	
All Hallows	Jean Barrilet	window (1962) *St Crispin*
	Hans Feibusch	painting (1952) *Christ appearing to the Disciples*
	Evie Hone	window (1955)
	John Piper and Patrick Reyntiens	windows (1961/9)
St Mary	Ninian Comper	architecture and furnishings (1908–31)
	Frank Knight	altar cross and candlesticks screen (c1930)
WINCHESTER	**Hampshire**	
Cathedral	Thetis Blacker	batik paintings, banners (1979)
	Ninian Comper	sculpture (1933) *Joan of Arc*
	Leslie Durbin	cross & candlesticks (1966)
	Alan Durst	sculpture (1944) *Annunciation*
	Hugh Easton	windows (1938/9)
	David John	processional cross (1979)
	Margaret Kaye	frontal (1960)
	Barbara Siedleska	copes (1979)
	Brian Thomas	shrine and canopy (1962)
	Christopher Whall	window (1920)
YORK	**North Yorkshire**	
Minster	Ninian Comper	pulpit and font cover (1946)
	C. Peers	candlesticks (1949)
	Harry Stammers	window and astronomical clock (1955)
	Lawrence Turner	reliefs (1923)
	Graham Wilson	paintings (1979) *St Edwin, St Hilda and St Paulinus*

Index